D1314560

How To Paint With
OILS
PETER JOHN GARRARD

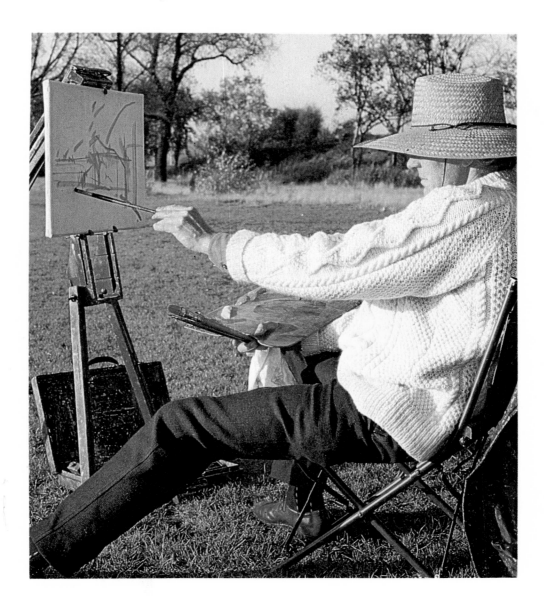

HPBooks

Published in the United States by
HPBooks
P.O. Box 5367
Tucson, AZ 85703
602/888-2150

Publishers: Bill and Helen Fisher
Executive Editor: Rick Bailey
Editorial Director: Randy Summerlin
Art Director: Don Burton

First Published 1980 by
Collins Publishers, Glasgow and London

ISBN 0-89586-160-7
Library of Congress Catalog Card Number: 81-85409

Notice: The information in this book is true and
complete to the best of our knowledge. All
recommendations are made without guarantees on the
part of the author or HPBooks. The author and HPBooks
disclaim all liability incurred in connection with the use
of this information.

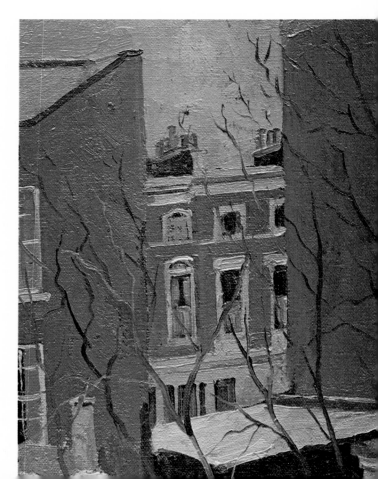

CONTENTS

Portrait Of An Artist— Peter John Garrard

Peter John Garrard was born in Peterborough, Cambridgeshire, England. He now lives in London with his wife, Patricia, and their three children. Garrard is a well-known teacher and painter. He is aware of beginners' problems and has helped develop art education for adults.

Following his formal education, Garrard taught Latin and rugby at the Summerfields, Oxford, prep school. He gave his first public lecture—on Emily Brontë—at age 17 to an undergraduate society at Pembroke College, Oxford.

While teaching at Summerfields, Garrard studied art in adult evening classes. He then joined the army and served in Greece during the civil war. He studied at the Byam Shaw School of Painting and Drawing in London when he returned to England.

While a student, Garrard won the Knapping Prize and twice won the David Murray Landscape Schol-

arship. He was commissioned to paint several landscapes and portraits during his final year at Byam Shaw. Since then he has pursued teaching and painting.

After leaving art school, Garrard worked for a firm of restorers. This experience gave him a lasting interest in the technicalities of paint.

Although he also draws and paints watercolors, oils have always been Garrard's favorite medium. He paints mostly realistic portraits and landscapes.

The appeal of Garrard's paintings is international. His work is on display in public and private collections in the United States, Australia, Canada, France, Germany, Poland and New Zealand. British public collections possessing his paintings include the Royal Academy, the Royal Hospital at Chelsea, the Royal Borough of Kensington and Chelsea, and Hull City Council.

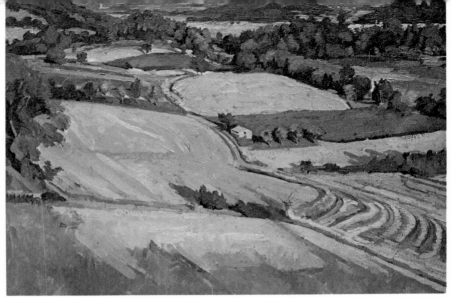

View from Aigaliers, 30x25".

Garrard's works have been sold at many art galleries in London and the British provinces, and in the United States and Switzerland.

He has participated in three representative overseas exhibitions of British painting. He has held three one-man exhibitions in London and has had pictures in most major mixed exhibitions in London.

Garrard was editor of *The Artist* magazine from 1972 to 1979 and has written articles on painting and drawing for numerous magazines. He was also the author of the ninth edition of *The Artist Guide,* published in 1976.

Garrard enjoys working with beginners, especially beginner competitions. He was chairman of the Shell and Brooke Bond children's competitions for several years. He has been chairman of the Inveresk Watercolor Painting Competition since its beginning.

Garrard has served as chairman of judges of the Spirit of London Painting Competition. He is a governor of the Mary Ward Settlement and the Camberwell School of Arts and Crafts.

He is vice president of the Royal Society of British Artists. He is also a member of the Royal Society of Portrait Painters, the New English Art Club and the Art Workers Guild. In 1977 he was awarded the De Laszlo Medal by the Royal Society of British Artists.

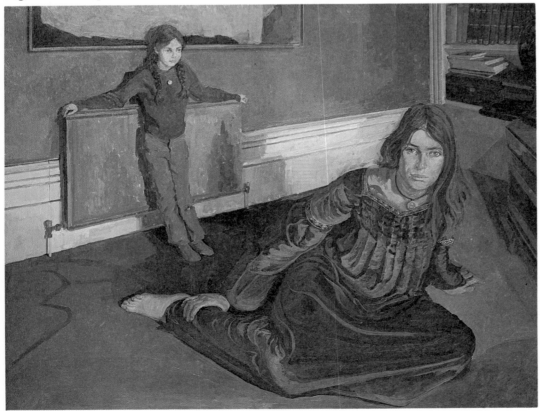

Virginia and Sophie, 53x42".
Collection of Jill de Brant.

Why Paint?

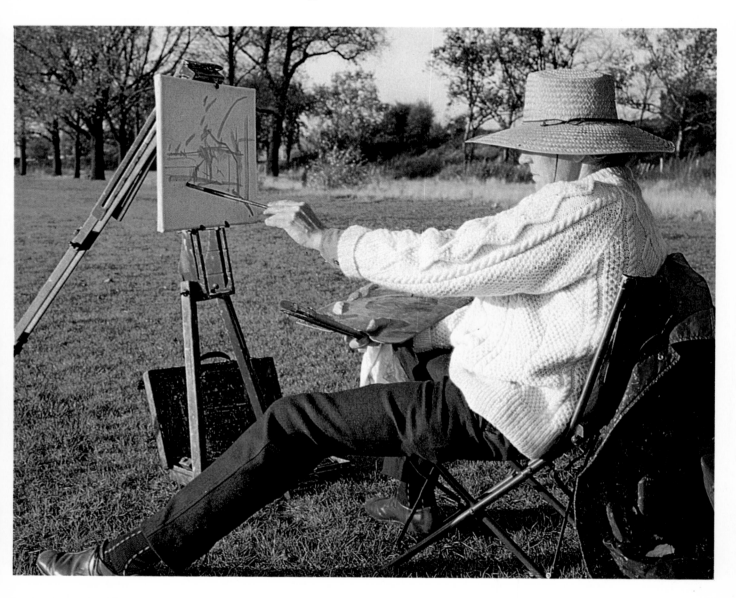

People often say to me, "I would love to paint, but I can't draw a straight line."

I usually tell them their drawing ability doesn't matter and to give painting a try anyway.

I try to encourage beginners, but people too often think they must master drawing before they can paint. Teachers know that drawing does matter. But we often fail to tackle the root of the problem. We start by trying to help the beginner improve his drawing. In other words, we accept his excuse.

When I was a student, I drew pictures of plaster casts for many months. Then I moved up to life drawing—drawing human models. Finally, I was allowed to paint a still life.

Before I started the painting, I drew the still life twice. The first was to plan the design of shapes, the second to work out values—or the range of lights and darks. When my teacher thought I had thoroughly understood these, I was allowed to put brush to canvas. Before I was permitted to put down any colors, I had to copy the design onto canvas. Then I had to work out value patterns with one paint—raw umber. I was eventually allowed to put some real color onto the canvas. I knew the subject well by the time I got to the color.

Actually, I knew the subject too well. The first excitement had gone. It was often difficult to remember why I wanted to paint that subject. More impor-

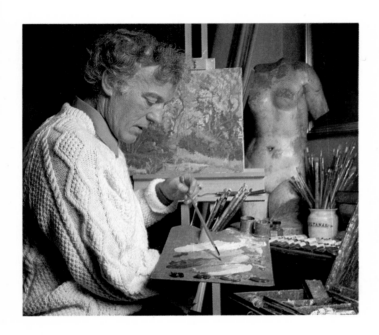

tant, it was hard to understand what my teacher meant by "good drawing," which he insisted must come first.

I was always asking myself, "Have I drawn well?" Finally, I began to understand what he was trying to teach me.

Here's the point of the story about my student days: *Start painting immediately.* Don't bother with anything else. I don't mean drawing is unimportant and the way I learned bad. I believe you can learn satisfactorily what is meant by drawing when you have done some painting. You will find I mention drawing often and try to explain what I mean by it. But I do believe the best way for you to learn is through painting.

I know many people who want to paint. The only thing they have in common is a desire to learn. But too many of them have a desire to paint the so-called *right* way. They remember a childhood teacher telling them drawing must be mastered first.

If I can rid you of this idea at the outset, I will be pleased.

Drawing is a big stumbling block for many people because they think of it as something at which they should excel. But it presents difficulties they do not understand.

Most people think of drawing as being done with a pencil. They think of it as getting the outlines "correct" and "filling these in" when they paint.

This is far from the truth. I think it is probably better to start another way. Paint first and discover from your own work why drawing is useful. You may go on to draw—even with a pencil—and understand how it can help you.

What qualifications are required to begin to learn about painting? All you need is a desire to paint and willingness to try.

One of the exciting things about painting—why it is different from all other arts—is that even as a humble beginner you can *express yourself*. The way you paint will be different from anyone else's. All I can do in this book is try to help you start on a worthwhile and absorbing study. You may be one of those who worries because you are starting to paint late in life—too late to do anything about it. Banish such thoughts. Even students well beyond their 60s can easily learn to paint.

You may worry that you can't devote as much time to painting as you would like because of other commitments. But most professional artists would say the same thing.

Some of my suggestions are designed to make it easier for you to go to the next stage more quickly.

There is one other quality I would commend—*patience*. Painting is a serious business. It is something you will enjoy. Don't be afraid to make mistakes—in painting, you learn most from correcting them.

Understanding Oil Paints

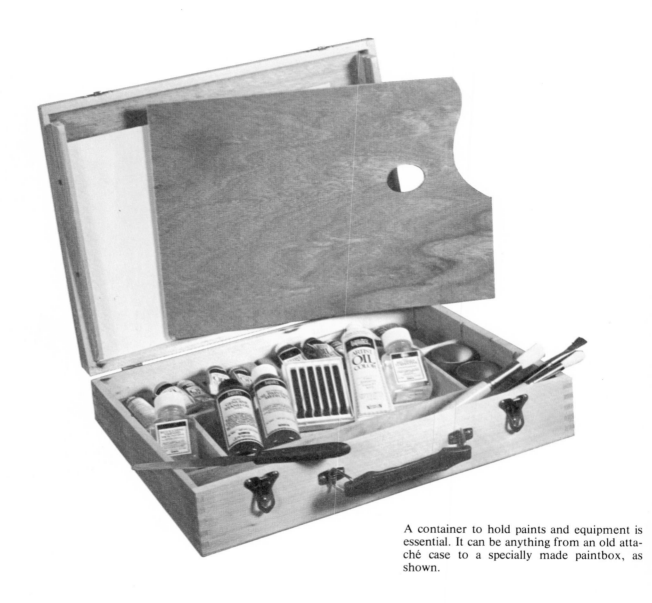

A container to hold paints and equipment is essential. It can be anything from an old attaché case to a specially made paintbox, as shown.

Painting with oils is one of the most exciting ways to paint. It is the *only* way to paint for me.

I like everything about oil paint. I enjoy working with it. I like the way it can be used thickly and thinly—the way that every brushstroke can be varied. Even the smell pleases me.

For me it is the ideal means of expression. I also like to draw. There are many occasions when drawing with a pencil is just what is required. But for sheer personal pleasure, I paint with oils.

Oil painting is perfect as a medium for the beginner. It is easy to correct by wiping it out or by paint-ing over it. The problem with other media, such as watercolor, is that corrections are difficult if not impossible. An example is when you realize a color should be *lighter*. With oils, you paint over the original color with the correct one. But with watercolor, you can only scrub it down, which is not always successful.

Another advantage of oil painting is that you can place dabs of different colors next to each other while both are still wet. They will blend into each other. This is one of the most useful ways of painting, which I will mention often.

Oil paints require careful treatment. The tubes on the right are improperly squeezed, which is wasteful. The tubes on the left show the proper way to roll them up as paint is used.

Oil painting provides you with a wide range of choices. You can paint rich, dark colors or pale, gentle shades. Oils lend themselves to *objective* painting. Yet many abstract painters prefer oils above all else.

There are some disadvantages in using oil paints. The long drying time may be the most serious one for many people. I find slowness of drying a difficulty only when I go on a painting trip and have to take home a lot of wet paintings.

This transportation difficulty can be overcome. If you paint on canvas, place *canvas pins* at each corner. Then you can place another wet canvas on top. The pins hold the two paintings apart.

If you paint on boards, place thin slices of cork between them at the corners and tie the boards together with string.

Some people consider the technical background required for oil painting to be a disadvantage. Actually, the amount you have to learn is small.

Why should a beginner bother with technical information about oil painting? It is necessary because if you ignore such details, a picture you paint today may be in poor condition in two months. It may crack all over, or the color may change. Technical knowledge will help you avoid these problems.

Here's a guideline to remember: Don't do the drawing or underpainting in ivory-black. It dries slower than other colors. If a bottom layer dries slower than a top layer, it will crack when the top layer dries. Understanding the technical aspects of oil paints will help ensure that your paintings last.

There are distinct differences between media. *Oil paint* is pigment based in *oil. Acrylic paint* is pigment based in an *acrylic polymer resin. Watercolor* is pigment mixed with *gum arabic* and several other ingredients. *Pure tempera* is pigment plus *egg yolk*—but there are variations of this. *Tempera emulsion* is pigment plus *egg yolk and linseed oil*.

So, paint is pigment mixed with oil or another substance. Yellow ochre paint is an example. Yellow ochre—a mineral—is ground with linseed oil to make paint. This simplification is not true of most paints you use, because the shelf life—or time a paint remains in usable condition—varies from pigment to pigment. Vermilion will harden in the tube in only two weeks if ground with linseed oil. In the early days of oil painting, vermilion was mixed with wax to slow its drying.

Present-day oil paint manufacturers have tried to solve problems and variations of each pigment so paints will have similar drying times and shelf lives.

There are unavoidable variations—ivory-black still dries slower than other paints. But if you use the lists given in the color section on page 14, you will encounter few technical problems.

I use artists' professional-quality oil colors. These are expensive, so I recommend you begin your studies with less-expensive student-grade oil colors. But purchase good-quality materials if possible.

Let me clarify some terminology used in this book. *Medium*—plural, *media*—refers to the different types of painting you can do, such as *oil, acrylic* or *watercolor*.

Medium—plural, *mediums*—describes additives you can use with paint to give it different characteristics. An example is *turpentine,* which is added to give oil paint a more fluid consistency.

Equipment

Equipment requirements are simple. When you choose equipment, ask these questions: Is it reasonably strong, so it will stand up to a lot of heavy use without breaking? Is it essential? Will it make painting more comfortable or make me more efficient?

You will collect things that are sometimes useful but not really necessary. Make a habit of occasionally cleaning out the room in which you paint. Be ruthless! I speak from experience, because I collect far more than I need.

A paintbox is useful. It doesn't matter if it's an old attaché case or a beautiful mahogany box.

I have several boxes. The one I like best is an old, cork-lined one that I acquired as a child. My father adapted it for me when I was a student. It has the minimum number of divisions for brushes, paints, oil and turpentine bottles, and a device for saving paint. It also holds a 10x14'' board in the lid.

In the division for brushes, there are palette and painting knives, two dippers, drawing pens and a paint rag. There is another rag on top of the tubes of paint.

Whatever box you choose, make sure it is long enough to hold your brushes and not too heavy if you plan to paint outdoors. Combination easel-paintboxes are lovely to look at, but I find they are difficult to carry if I want to walk a long distance.

I sit on a chair or stool when I paint outdoors. I like a small, light chair with a back, so I can lean back comfortably. I have tried most of the types available. The only one I don't like is the small folding metal stool because it causes cramps in my thighs.

Your chair should be strong and easy to carry. Don't choose a comfortable, lightweight garden chair. They are fine for sitting, but the arms restrict your movements when painting.

In the studio I use a chair with a back and a high seat. Because my head is almost at the same height as when I stand, I can draw sitting down. When I stand to paint later, I see objects or my model from approximately the same height.

I keep my palette beside me on a tall kitchen stool, where it is easy to mix paint. Many of my colleagues use old wheeled tea tables or a series of compartments on wheels.

The top level of a table can serve as an excellent palette. Lay down white paper and cover it with a sheet of glass cut to size. This is easy to keep clean and is a good surface for mixing paints.

If you like painting portraits, a platform is necessary to raise the level of the model in relation to your viewpoint. You should not look *down* on them. My platform is 4-1/2 feet square and 11-3/4 inches high. It is on castors so it can be moved easily.

A background screen is helpful. You can hang material over it to change the color of the area surrounding the model.

You may have a spare room to convert into a studio. This is ideal. It means you can leave things out, ready for use. You don't have to set up the room each time before you start to work.

I believe it will help you to keep paintings where you can study them and see what should be altered. I have worked in many different rooms. My only concern is a good source of light. A window facing north—allowing a north light—is best in the northern hemisphere. It gives the most consistent light, whatever time of day you work. In the southern hemisphere, the reverse is true.

Do not have carpets on the floor. Sooner or later you will spill something. If you have to work in your living room or kitchen, a large sheet of heavy plastic is good protection for the floor.

A **Easel**
B **Painting knives**
C **Plaster cast**
D **Linseed oil**
E **Spare brushes**
F **Tubes of paint**
G **Brushes in use**
H **Paint rag**
I **Dipper cup**
J **Palette**
K **Paintbox**
L **T-square**
M **Retouching varnish**
N **Turpentine**
O **Adjustable magnifying glass**
P **Spare dipper cup (double)**

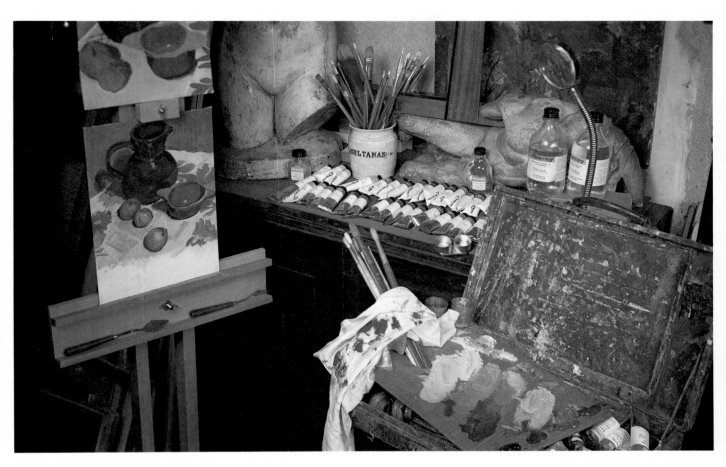

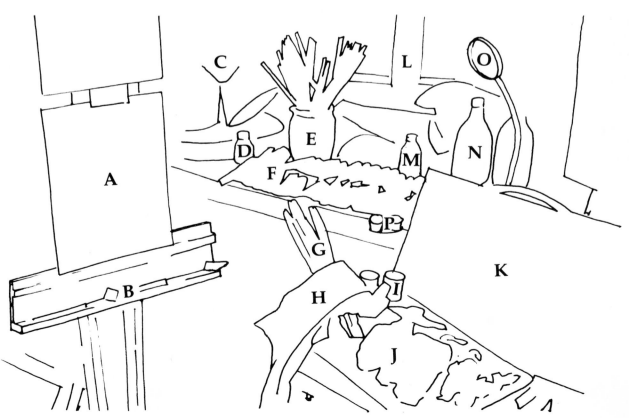

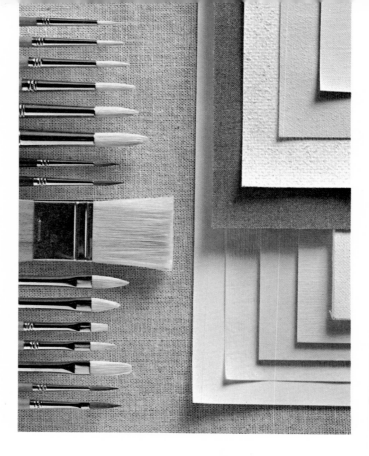

BRUSHES

There are three main types of brushes. One is hog bristle, which is fairly tough. Another is sable, which is soft and springy. There are other soft brushes made from ringcat, ox or squirrel hair, and less expensive mixtures of hairs. But none are as springy as sable. There are manmade fibers, usually a form of nylon. Some are very good and inexpensive.

A good brush wears well and returns to its original shape quickly. Sables are the most expensive.

Good brushes are essential when you start painting. I recommend you purchase round hog brushes, two of each size. Sizes are indicated by number, such as No. 1, 2, 3, 4, 5 and 7. Round hog brushes give you a greater choice of strokes you can make.

Four round brushes are shown at the top of the photograph above, starting with the smallest. I also recommend two fine sables, Nos. 4 and 5, shown immediately below the round hog brushes.

The next brush illustrated is a wide varnish brush. There are many other shapes, long filbert to short square brushes, which you will find useful later.

They are all useful, and you should try them. But each restricts the kind of brushstroke you can make. A square brush makes a square brushstroke, which can be tedious if repeated in all your paintings. The shape of brush you enjoy using is a personal decision you can make as you gain experience.

PAINTING SURFACES

You can paint on a variety of surfaces with oils, ranging from inexpensive paper to expensive canvas. The important thing to remember is that you want the oil paint to adhere to the surface. But you do not want it absorbed so completely that the oil is drawn out, leaving behind an unstable pigment that will flake off.

If you paint on ordinary writing paper, the oil is rapidly dispersed and forms a halo around the paint. The paint dries almost immediately. Paper is a difficult surface for oil painting.

Painting surfaces are shown on the right in the photograph above. These include *specially prepared paper* for sketching, an *oil painting board, canvas panel, stretched canvas,* a piece of *unprimed canvas* and three kinds of *primed canvas.*

Oil sketching paper is the least expensive. But it's not easy to use because it is too smooth. You must put a coat of paint on it first to provide a bondable surface for your paint. Canvas is made of cotton or linen and can be smooth or coarse.

The best surface is linen. You will have to paint more thickly and leave touches of paint alone with a coarse canvas.

I have painted on wood, canvas and paper. For large works I use canvas and for smaller works, canvas boards. I recommend you use canvas boards at first because they have a *tooth*—or surface texture—that holds paint and helps you apply it.

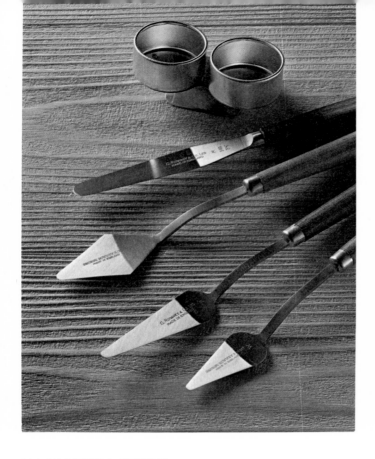

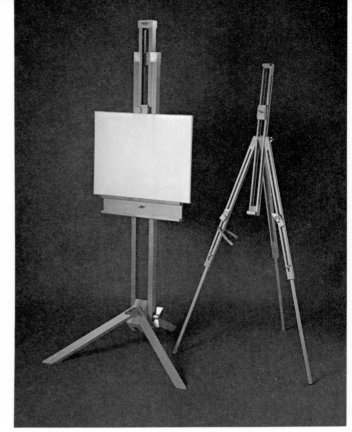

PALETTE CUPS
AND PAINTING KNIVES

A double palette cup as shown above is an important piece of equipment. One cup is used for cleaning brushes, the other for holding painting mediums. The best type is a 1-1/2-inch double cup. Sometimes I use a single cup, such as when I am doing an underpainting in one color.

Palette knives with straight blades are for mixing paint and cleaning the palette. Painting knives are more flexible. They are designed for putting paint on canvas.

There is a wide variety of knives available. I have found the shapes shown above the most useful. These are the knives I used for the palette knife paintings discussed later, beginning on page 60.

EASELS

An easel should be rigid and capable of holding the size of canvas or board you require. It is helpful if the easel's height can be adjusted. Then you can work more conveniently on different parts of the painting.

In the studio, you want an easel that can hold a larger canvas than you would normally work on outdoors. The studio easel illustrated above on the left will hold a canvas up to 77 inches high.

This studio easel is the universally accepted design. It is firm, not too heavy, and foldable. I have painted larger pictures on such an easel with an arrangement of hooks and string to hold it rigid.

You will need an easel of lighter weight when you paint outdoors. The one shown at right is the best design available. With it, you can sit or stand to paint. Many portable easels do not allow such flexibility. The outdoor easel will hold a canvas up to 50 inches high.

The head of the easel holds the canvas or board at the top. It is reversible to hold either small boards or larger canvases. In windy weather, a weighted string hanging from the center keeps the easel rigid. I hang my paintbox on the string as a weight.

Both easels tilt so you can position the canvas at an angle that does not reflect the sun.

Range Of Colors

In the lists that follow, I have divided colors into groups denoting different degrees of usefulness. Generally, it is better to use a small range of colors and explore what you can do with them. A color wheel will show you how to mix a variety of colors with relatively few paints.

Add different colors only when it becomes essential. You may have only cadmium red on your palette, but you may want to paint a dark red object. Then you would add alizarin crimson.

BASIC COLORS

Flake White Or Titanium White—Flake white has been used for centuries. It dries quickly and has body. I prefer it, but many painters like titanium white. When I refer to white in this book, I mean flake white.

Yellow Ochre—This is a general-purpose yellow. When mixed with white, it becomes a bright yellow. It is a useful color in almost all mixtures.

Cadmium Red—This is necessary not only for painting red objects but also for warming up other colors.

Viridian—This is probably the most difficult color to handle, but green is essential on your palette. Sometimes you may want to make something greener. Mixed with yellows, viridian can make a lovely series of different greens.

Ultramarine Blue—This is the best general-purpose blue paint.

Ivory-Black—This is the "blackest" black. Think of it as a color, not a darkening agent. Claude Monet and other Impressionist artists found it essential for most of their work.

USEFUL COLORS

These are colors you will often find useful. It is difficult to paint a lemon if the brightest yellow you have is yellow ochre.

Lemon Yellow Or Cadmium Yellow—These will produce much brighter yellows in mixtures.

Alizarin Crimson—This deep, strong red is sometimes essential, but it's a difficult color to paint with. It tends to get into everything. Try using it and you will see what I mean.

Burnt Sienna—This is the best universal brown.

Cobalt Blue—It is much like ultramarine blue, but I find cobalt blue useful because of its "softness."

Cobalt Violet—Cobalt violet is sometimes necessary, although you can make a violet by mixing red and blue.

COLORS FOR OCCASIONAL USE

Cadmium Orange—This is a good orange for special needs.

Light Red—This strong brownish red can be pleasant, but it is difficult to handle.

Cerulean Blue—I seldom use this blue, but many painters find it essential.

Raw Umber—This is the fastest-drying color. It is excellent for underpaintings.

Terre-Verte—This is a green that many people find useful when painting portraits.

Cobalt Green—This green is not as strong as viridian.

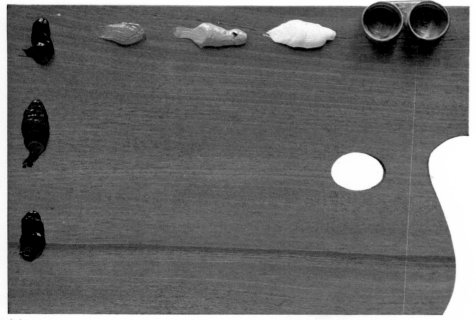

Colors on this palette are arranged from light to dark for a right-handed artist. Note the amounts of pigment.

Colors On The Palette

It is important that you develop habits to save time. One of these is to lay out your palette colors in the same way and same place each time.

When I paint, I don't have to look to find ultramarine blue. My brush automatically goes to the same place. Imagine a good pianist. His fingers go to specific keys because he knows where they are without looking.

Orderliness on the palette is also helpful when you are working outdoors in bright light or indoors in dim light. Knowing where your colors are prevents confusion under such lighting conditions.

There are many ways to organize colors on your palette. Any method you use should work with your kind of painting and should remain unaltered unless you make a major change of style.

Your method should be sensible. Don't choose odd arrangements because they look pretty on the palette. Your palette is where the real work takes place. When you put a stroke of paint on your canvas, it should be the color you intend. You should have worked it out to the best of your ability.

Don't put colors on the bottom edge of your palette—the lowest edge in the illustrations below and opposite. It is hard to pick up the correct amount of color from the bottom edge. Try it for yourself and you will discover that you have to hold your brush in a different way and concentrate on picking up the color.

Two useful color layouts are illustrated here. On the palette at left, colors are in order from white to black—light to dark. In the corner is green. The warm colors—yellow and red—are on the top edge.

The cool colors—green, blue and black—are on the left.

The palette below is organized for a left-handed painter because I am left-handed. The big difference in color layout is that white is in the middle. At the top are the warm colors, with the lightest nearest to white. Even right-handed painters may prefer this color layout. Reverse the order, leaving white in the corner.

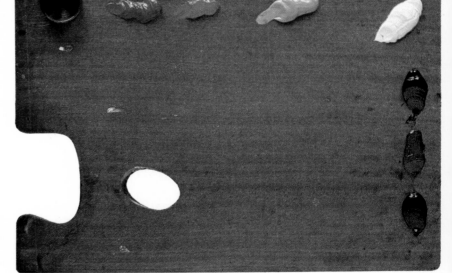

This is an alternative method of arranging palette colors, showing how a left-handed artist can do it. White is in the middle, warm colors are at the top and cool colors are down the side.

15

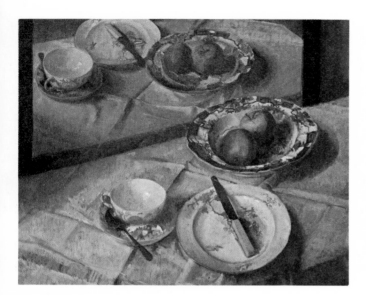

Still Life with Mirror, 30x25''.
Collection of Vera Taylor.

Brown Field, 10x8''.

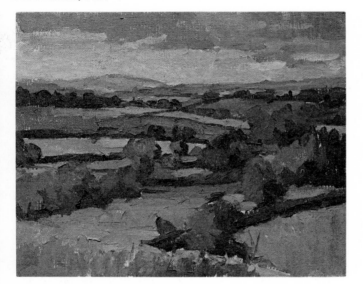

Choosing Subjects

The first guideline is to choose subjects you like to look at. There are four main types of subjects you can paint: still lifes, landscapes, people and imagined subjects. I add palette-knife painting as a fifth category of painting because some beginners find they have more trouble with paint when working with brushes.

Whatever the subject, make sure it has a number of different colors and is not too simple. Paint the objects large. If they are too small, you will have difficulty manipulating the paint. Correct placement of each dab of paint becomes too important in small subjects. This idea is demonstrated in the two drawings at the bottom of the page. Let's analyze the paintings on this page and the next.

Still Life With Mirror—Try painting objects left on the breakfast table. Don't set up special still-life arrangements. In this painting I wanted to explore values—or the relationship of lights and darks. Everything in the mirror is a little darker than it is seen directly. I did not spend a long time setting it up. I let the reflections in the mirror dictate the design. Note the large size of the objects in relation to the overall canvas.

Brown Field—Try painting the view from a window of your home, whatever it is like. You won't have the problem of flies on a hot day or rain on an overcast day. Even a brick wall can be interesting to paint. In *Brown Field,* I didn't bother with the design. I drew a few lines to indicate the edges of the fields or clumps of trees and then started to paint. I worked out the relationship of each color to the others in the landscape.

The subject below may be interesting to paint, but details of the town would be too difficult for a beginner. Each object would be too small. I would suggest painting the area within the dotted lines. The sketch on the right shows the scale of objects as they would be on the board or canvas.

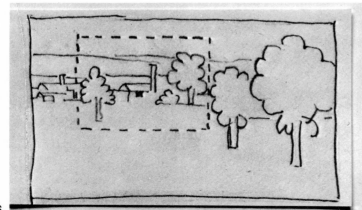

Miko Russell—If you want to paint people, get a friend to sit for you. Make sure he won't mind if the painting doesn't bear resemblance to him. You may think a good likeness is essential, but that is a problem to tackle later after you have done a few paintings. Paint a head or a figure in a setting. You can work out a head portrait simply. Miko Russell is a musician and singer. I painted him in an Irish pub. This was one of the best exercises in concentration I ever had! I was concerned with his head, but not with the jersey and background, except the colors.

Adam and Eve—The information in this book is intended to help you learn to observe by painting from Nature. You may want to work from imagination. It is best to refer to sketches, however rough they may be. They will help you plan the design you wish to paint. It's better if this can be done from Nature. Try to think of variations on your theme. Better still, paint several versions at once. *Adam and Eve* is a remarkable painting for an inexperienced artist. The design is well planned. It took a long time to paint. It is ambitious for a beginner, but it is a good model to study.

Provençal Landscape—When painting with a palette knife, as in this oil, you must be sure the scale of subjects is not too small. You must not paint slowly and hesitatingly. You will find it difficult not to do so with a knife. This technique is discussed on pages 60 to 63. Painting with a knife is a useful but different way of creating pictures. The palette knife lends itself to certain subjects more than others. You will understand this better when you try it. Some artists paint every subject with a knife. This method is useful to the beginner who gets bogged down or finds all his colors appearing muddy.

When you begin painting, it is better to put down paint and not worry about doing it the *wrong* or *right* way. Gradually try to pick up good habits. Concentrate on ideas you want to express—but don't be obsessed with habits. They are a means to an end, not the end itself. Draw the picture on your board or canvas with one color—not black or white—then paint.

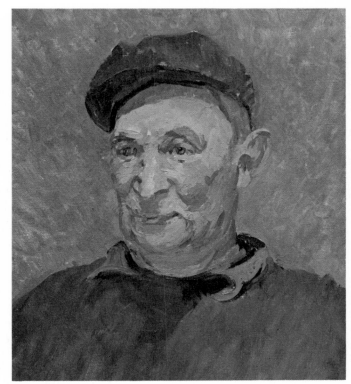

Miko Russell, 14x18''.

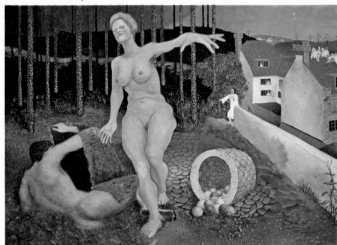

Adam and Eve, by A.E. Webb, 48x36''.
Collection of *The Artist* magazine.

Provençal Landscape, 14x10''.

Start Painting

Drawing When You Paint

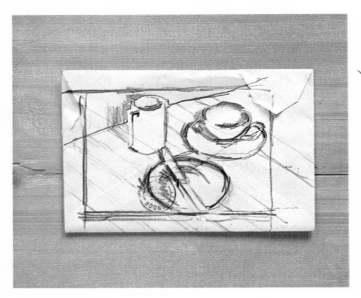

I have said that it is important not to worry about learning to draw before you paint. I am insistent about this because more beginners worry about draftsmanship than any other facet of painting. I believe it is more useful to develop skills as you go along when they become necessary.

When you can't further improve until you do something about your drawing, then quit painting temporarily and make careful drawing studies. There are ways of using drawings to save time.

Before starting to paint, determine the extent of the subject you want to portray. Decide the shape and size of your painting surface. Vary the sizes of your paintings unless you must produce a particular size for a friend or exhibition. Try to paint a small picture, then a large one. You will learn from both.

Make a sketch rather than a drawing on any scrap of paper. The illustration at top left shows a sketch I made on the back of an envelope.

I sketched the subject roughly and decided I would concentrate mainly on three objects. I sketched the shape of the painting board I had in mind and began to look more carefully at the shapes of objects. Notice where I refined shapes with slightly heavier lines.

Make several sketches and think of different shapes. Decide whether you want a vertical or horizontal painting.

Some subjects dictate a particular shape immediately. Even when this is so, study it in other shapes. A square painting is unusual but occasionally may be just what you want. At other times you may find it difficult to decide shape. Then choose a shape arbitrarily and see what happens.

In painting, nothing is as useful as experience. But remember that a shape you find unattractive on one occasion may be perfect for another painting. Experience must always be tempered with experimentation.

Both sketches on this page are rough. I use them as aids to thinking, and don't worry about how good they are.

The marks made in the still life with a jug below left show more clearly how I changed my mind. Note how I altered the vertical dimensions, gradually bringing them in closer. By the time I finished this sketch, I knew what I wanted to do. I was able to move on to the painting. Both sketches led to paintings reproduced in this book.

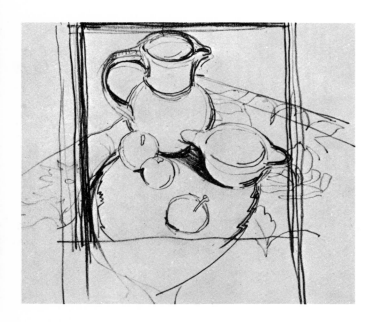

The sketches above are the type you will find useful. Regard them only as notes for reference, planning and working out design problems.

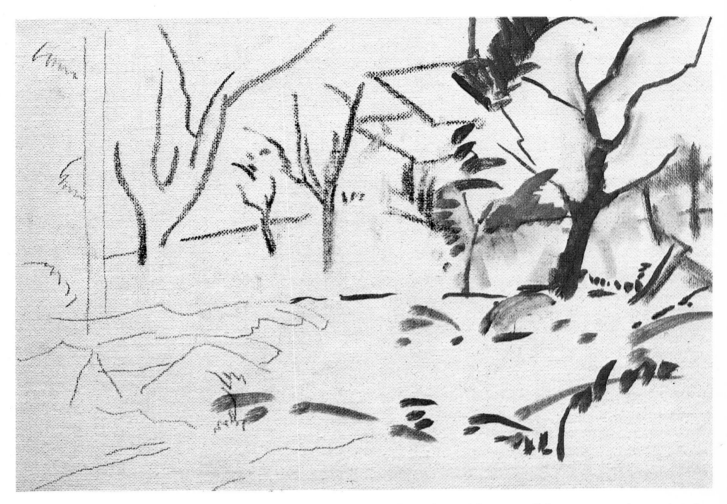

When you have studied your sketches to plan your painting, it is time to move on. You can use the sketch to make a careful drawing. But it is better to start immediately on the painting.

A lot of nonsense has been written about how to draw on your board or canvas before you paint. In the illustration above, I tried all the suggestions. On the left, I drew in pencil, changed to charcoal in the middle and then used one color—ultramarine blue—and turpentine on the right.

Charcoal drawing like that above is not a good method. On a board with any grain or tooth—rough surface texture—it's inaccurate. Does the thickness of the tree trunks I have drawn in charcoal extend to the edges of the charcoal mark, or is the tree shape determined by the inside of the mark? When you paint over such marks, the charcoal is picked up by your paint. The paint immediately becomes gray. The change of color can be extreme if there is a lot of charcoal.

Some people try to preserve charcoal drawings with fixative or by drawing over the charcoal lines with a sable brush and pigment, which is laborious. Using fixative with your initial drawing is technically a bad method.

Drawing with a pencil is not a good practice, because in time the strong pencil lines may show through the painting. The most useful way of doing the preliminary drawing is as I have done on the right, using one color and turpentine.

Many beginners seem reluctant to draw this way on their canvas. But with practice it is fun and efficient. When I paint outdoors, or when I am concerned mostly about color, I draw with ultramarine blue or cobalt blue. You can vary the color you use as long as you don't use ivory-black, because it dries too slowly. Don't use white or yellow ochre because they are difficult to see. A good alternative is blue or red.

I draw with raw umber when painting indoors, or when the design is particularly important. I use this color because it dries faster than any other color and doesn't delay applying subsequent layers of paint.

The secret is to paint with a thin sable brush, using lots of turpentine. Put lines down firmly. If they are incorrect, alter them with a rag moistened with turpentine. You can learn to draw by taking pigment out or pushing it around with a rag.

Don't mix white with color for the preliminary drawing. Use only the color and turpentine.

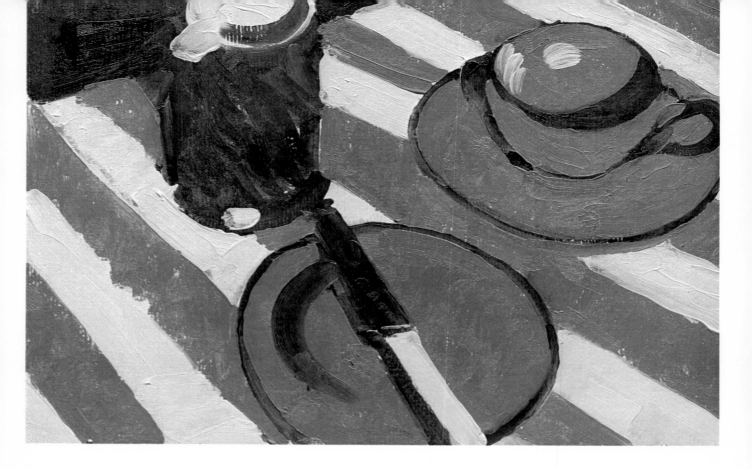

Painting Values
With One Color and White

Value is the difference between the lights and darks of objects when compared to each other. It is one of the qualities you must consider when mixing each color. Other mixing factors are the *hue*—the name of a color, such as red, green, blue or black—and the relative *warmth* or *coolness* of objects compared to each other. Warm and cool colors are discussed in detail on pages 30 and 31.

When you mix colors on your palette, ask yourself three questions: What is the hue of the object? What is its color value compared to surrounding objects? What is its relative color warmth or coolness?

Sometimes it helps to do exercises that deal with just one of these qualities. As an example, try painting everything in three values: *light, middle* and *dark values.*

The still life above has been painted in three values. Compare it to the illustrations in the still-life section, pages 22 through 25. I used raw umber, flake white and turpentine. I put large quantities of white and raw umber on my palette. I mixed some of each to produce a color value about halfway between the two, as shown at left. I painted the still life with these three values. It's a little stark, but it helps you visualize the main changes needed in a painting. This exercise also makes you aware of the shapes of objects.

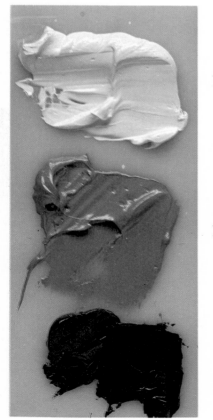

Light

Medium

Dark

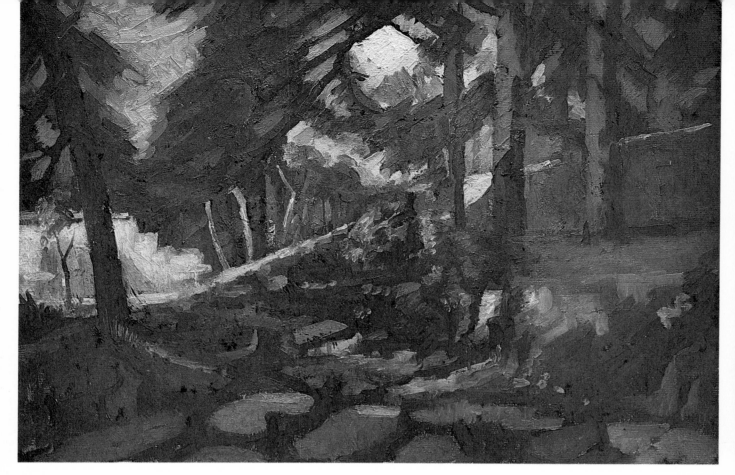

Devon Landscape, 14x10".

Another exercise is to mix five equally different values ranging from pure white to pure raw umber. An even more difficult exercise is to construct a scale of nine values, the difference between any two values being the same as the difference between any other two.

I varied the values considerably in *Devon Landscape*. There are many more than nine values. I paid particular attention to small changes between one object and another. I used ultramarine blue and flake white in this painting to show that value is not the difference between black and white, but is the difference between *dark and light.*

Think of black and white as colors. You can darken or lighten most colors, but it is difficult to lighten pure flake white or darken pure ivory-black.

There are some general guidelines about lightening and darkening colors. You can darken flake white with every other color. You can darken yellow ochre with cadmium red and lighten ivory-black with everything except ultramarine blue—you would hardly notice any difference if you mixed these.

Mixing theory is important to painting. When you look at a landscape, trees in the distance appear paler even though they are the same color as nearby trees. There is a difference between the light and dark side of the trees in the foreground of *Brown Field* on page 16. Note how some of the distant hills are lighter in value.

Awareness of value differences and the ability to paint in values can be two of the most interesting aspects of painting. Careful placing of values can unify your picture. The rough sketches in the portraits on pages 48 and 49 are value drawings to help sort out the design and shapes of the two pictures.

Compare the value range in *Devon Landscape* above and *Still Life with Blue Mug* on page 23. There are subtle differences. If you place a dark stroke of paint on a light one, the contrast is great. But if you place a dark accent in a middle-value area and make some gentle changes around it, the effect is more interesting. You can emphasize a shape by making a strong contrast, such as the dark tree against the light area above on the left.

Still-Life Studies

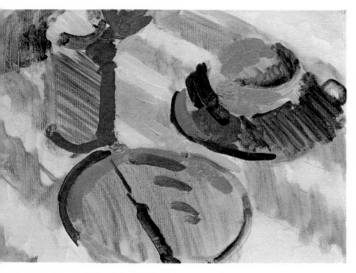

Every stroke of paint was considered in this stage. The final painting was done on top of this initial painting.

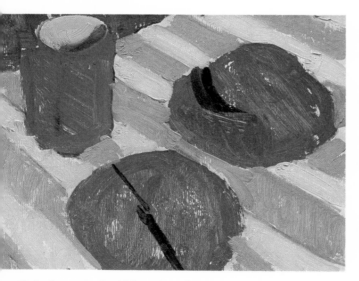

Only the general middle value of each color has been used here.

A Simple Still Life

Not everyone likes to work the same way. At left are two ways of beginning a still life. Both methods are equally good. The one you use will be determined by personal choice.

In the top painting, I first did a light-value drawing in raw umber and turpentine. Then I mixed colors on my palette. I used a different brush for every change of color and mixed everything I was going to use. In each case, I mixed a small quantity—not enough for use—but enough so I could see clearly what each color looked like against the others. The purpose of this was to compare the colors I was mixing away from the objects and distractions. At this stage, it is easy to start again. Later it is more difficult.

I started painting in the middle where a number of objects were adjacent to each other. I put down some of the dark-blue edge of the mug and placed against it a stroke of the white cloth. Against that I put the yellow of the cloth. Then I placed a brown stroke—the edge of the plate.

I moved over to the dark edge of the saucer and on to the lighter part of the saucer until I reached the dark shadow at the back of the cup. I built up the painting this way. The finished painting opposite was done on top of the preliminary painting at top left. Every brushstroke I put down was important. I tried to make it the right color in the right place.

The lower left example was begun slightly differently. With a sable brush and raw umber, I lightly drew the outline of every object. These outlines have been covered up by the paint. As carefully as I could, I mixed the middle-value colors of each object. Finally, I painted these in swiftly.

Every artist uses this method of painting from time to time. The only difficulty is that you have to judge the exact middle value, something most beginners find difficult. But it is a good way to work. The next step is to paint the darker and lighter colors onto this middle value.

The completed still life shows how I worked deliberately and carefully. I tried to paint as close to Nature as I could, putting stroke upon stroke, slightly modifying each area.

I used the basic palette—flake white, yellow ochre, cadmium red, viridian, ultramarine blue and ivory-black. I added lemon yellow so I could make a brighter yellow.

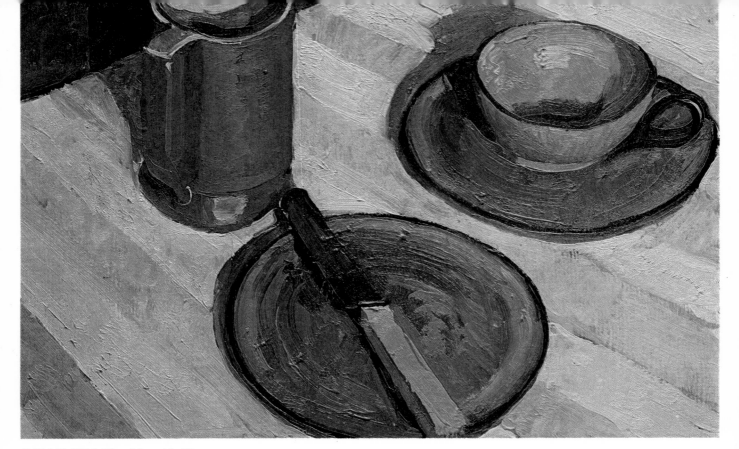

Still Life With Blue Mug, 10x7''.

I did not use any brown. The raw umber was used only in the underpainting. The pigments at right show how I mixed some of these colors. In each mixture illustrated, there is a dark and light version. In two cases there are three. You can see more than these in the still life.

Study the mixtures and practice making up colors this way. It's surprising what you can achieve by varying the proportion of colors. *Mix colors on your palette, not on your painting.*

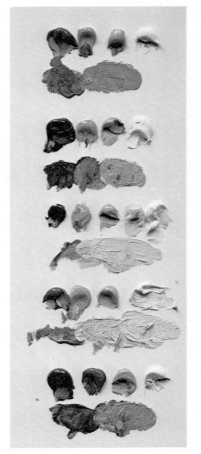

Blue mug

Plate, cup and saucer

Yellow cloth

White cloth

Wall

23

A More Complex Still Life

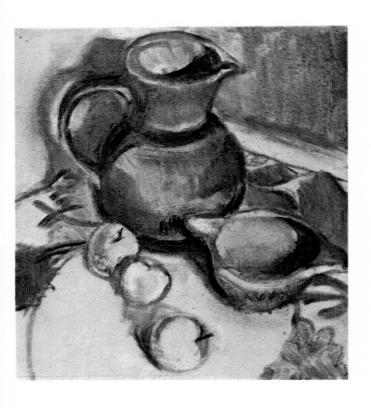

The underpainting at top left was done with raw umber and turpentine. It is based on the lower sketch on page 18. With a hog bristle, I started drawing coarse outlines of the jug, the edge of the cloth and the pot. This was done to see if I had the scale right—I did not copy the sketch directly. When I was satisfied with the underpainting, I developed each object more carefully.

I used a rag dipped in turpentine to help get accurate shapes of the objects. You can see where this was done in the foreground apple. I use this type of underpainting to study the subject and to see what some objects look like against each other.

I painted this in the evening by artificial light during the first painting session. Shadows are difficult in such light and I wanted a chance to work with them.

This is not an accurate value painting. The apples are too light against the cloth. It is only a development from the earlier sketch, observing everything intensely.

Generally, I start with the lightest colors. In this case I started with the cloth, because it was the nearest to white. I mixed the color in the area just above the apple and below the brown bowl. For the cloth I used white, yellow ochre, ivory-black and a touch of cadmium red. Later I added a little blue.

Then I painted the apples. Both the warm and cool apples have been made with the same mixture of colors—yellow ochre, cadmium red, a touch of alizarin crimson, viridian and white—but in different proportions. I used the same colors for the bowl with ultramarine blue instead of viridian. Finally, I painted the jug with viridian, ultramarine blue, yellow ochre, ivory-black and white.

I mixed three or four colors for each object, using a different brush every time. At this stage I was holding 12 brushes. Some of the colors were similar, so I occasionally used the same brush for more than one object.

The purpose of so many brushes at the beginning is to analyze each color clearly. If there are traces of other colors on your brush, it is easy to get confused when you want to mix a certain color again.

I added lemon yellow and alizarin crimson to the basic range of colors. I did not use raw umber. Some painters may suggest that it would have been easier to paint the bowl if I had used light red. But light red is not an easy color to handle. I was able to make a rich brown from the basic colors and alizarin crimson.

In the second evening's painting session, I started from the center—the dark at the base of the green jug. From there, I gradually worked outward. You

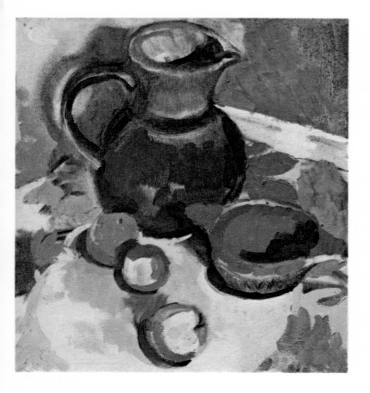

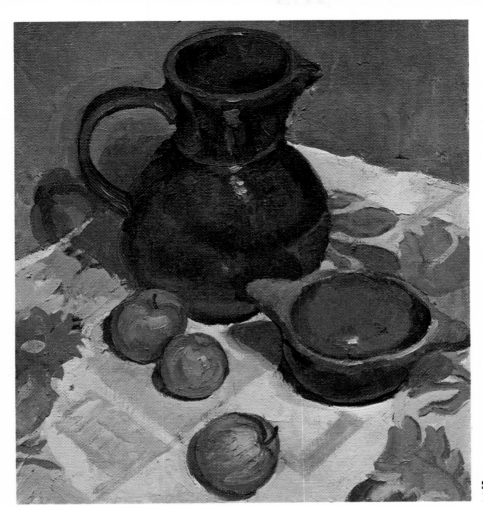

Still Life With Green Jug, 10x11".

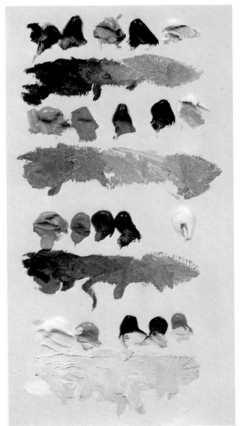

Jug

Apples, warm and cool

Bowl

Cloth

can see the point I reached by the end of the evening in the lower left illustration on page 24. Compare this with the finished version above. Note that the yellow cloth in the left foreground was too dark at first.

In the third evening's session, I spent a long time mixing the same colors I had used before. These colors are shown at right. Then I went on with the painting. The following night I repeated the mixing and finally produced the finished painting above.

I advise you to do your thinking on your palette. Put the results of your thoughts on the canvas.

Practice in mixing colors is probably more helpful to the beginner than anything else. It's not an abstract exercise but a way to learn how to judge colors accurately.

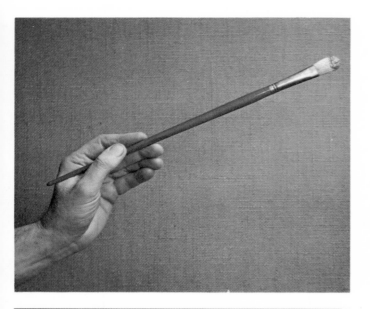

Basic Oil Techniques

The next four pages describe several basic techniques you should learn.

HOLDING THE BRUSH

I like to hold my brush at the end as shown at left. This allows the greatest possible movement. Many painters prefer to hold brushes about halfway down the handle. Whatever you do, don't hold it on the metal ferrule near the bristles. That will restrict easy movement, and you will get so near the picture you can't see enough of it. Getting too close will cause you to hunch your back uncomfortably. Work with your arm extended as much as possible. This keeps you away from the painting. You will be able to see it as a whole and judge one part against another. Thomas Gainsborough used brushes 5 feet long. I use 3-foot-long brushes when working on large paintings.

HOW TO USE A PAINT RAG

I prefer brushes in good condition, but I have painted with brushes in poor shape—they were loaned to me! Rags help keep brushes in good condition. I never paint without a rag, even if it means tearing off my shirt sleeve. The rag—which should be made of cotton, rather than manmade fiber—is looped over the little finger of the hand holding the palette. Use it by picking up part of the rag with a brush and putting it into the palm of your hand. Close your fingers around it and draw out the brush, as shown at left. The photo illustrates a left-handed painter. The rag has two functions: to clean your brush by closing your fingers firmly around the brush or to bring paint down to the tip of your brush by pulling the brush gently through your closed fingers.

HOW TO HOLD BRUSHES AND PALETTE

I am holding a rag, brushes and palette in the lower left photo. I am also holding a *mahlstick*. Here's how a mahlstick is used: Rest it on the edge of your canvas. Then you can steady your painting hand on it. It is especially useful when painting small details. You will be uncomfortable when you first try to hold your palette and other equipment. But you will soon learn it is more practical.

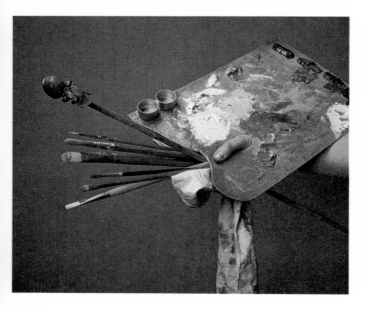

HOW TO CARE FOR BRUSHES

In the photo at right, the three brushes on the left side have been rinsed in turpentine and then washed with household soap and water. The best way to get brushes thoroughly clean is to put some soap on the bristles and scrub them in the palm of your hand. Do this under cold running water. Make sure you thoroughly rinse out the soap. The brushes will splay out after some use. To get them back to a good shape, wrap the bristles with a strip of paper towel while they are still wet as shown by the center brush. As the paper dries, it contracts and pulls the bristles back into shape. The brushes on the right have been subjected to this treatment. The brushes on the left are clean, but they have become slightly stained with a dye color. If you take care of your brushes, they will last a long time.

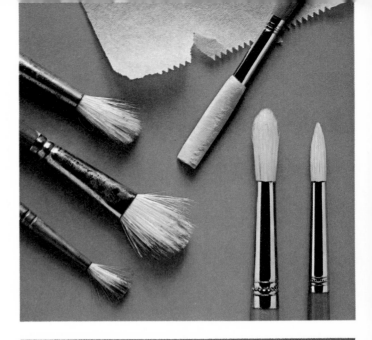

HOW TO STACK CANVASES

Take care of your boards and canvases when they are new and after you have painted on them. When new, stack them as shown at right. Then it is easy to see the sizes. Avoid marks on your canvas. If the canvas is good quality, you can get out mark damages by dampening the area on the back and wiping the front. If the canvas is cotton, it is impossible to remove such damages. When you have painted on canvases, do not stack them face-to-face. Face them against the wall at a steep angle to avoid spoiling the edges of the canvas.

PALETTE SHAPES

Below are two common palette shapes. The rectangular palette at left comes in a variety of sizes. Very small ones are not useful because there is not enough room on them to mix colors. The best size is about 14x9". The studio-shaped palette on the right is approximately 24 inches long. It is curved so you don't have to stretch too far to reach the paint and to make it easier to hold. Rub linseed oil into a new palette for a few days before using it. Also oil it after you clean it at the end of a day's painting. This stops the paint from sinking in and gives you a good working surface. Flexible plastic palettes and disposable palette pads are also available. Their main advantage is less trouble when cleaning up.

THICK AND THIN PAINT

It is a joy to work with thick or thin oil paints. Be versatile with paint from the beginning. Ideally, dark colors should be painted thinly and light colors thickly because light colors are more expressive. Every now and then, paint the light areas as thickly as you can. This will be obvious in your first several paintings, but with practice you can make changes in thickness more subtle. If you have painted one area thickly and want to paint over it, it's best to scrape the thick paint off with a penknife or palette knife. You should learn to paint from thin to thick as shown in the top left photograph. This allows the bottom layers of paint to dry more quickly than those on top. Thick paint dries more slowly. Most people seem to think of thin paint as "staining" the canvas. The technique can be nice to look at, but it is not a useful way for the beginner to work. It is important that you put *enough* paint on your board or canvas. This enables you to see if you are painting the right color. If you paint too thinly, the color has a different appearance because of the drawing underneath.

APPLYING PAINT

There are many ways to apply paint. The most dramatic difference is between a palette knife and a brush. In the lower left photo, the brown paint was applied with a knife. All the other colors were applied with a brush. These are your most common tools, but you can also use your fingers. The handle end of your brush can be used for certain effects, but do this infrequently. There are special fan-shaped brushes for blending edges. If you like using large amounts of paint, house-painting brushes can be useful. There is a whole series of airbrushes. They range from one that will produce a pencil-thin mark to others that will give a wide band of color. Palette knives will make different marks according to their shape. You can apply paint in thick bands or layers, or small, thick touches. When using a brush, remember to keep paint on the tip. Don't squeeze it halfway down the bristles in an uncontrollable lump. You can put the paint on in gentle strokes when your brush skims the surface and only the paint touches the board. You can scrub it into your canvas vigorously. You can cover an area with rapid, thick strokes or slow, deliberate ones. There are two ways you should not apply paint: one, as a house painter does, backward and forward over the same area. This tends to create a dull, lifeless effect. The second is by mixing colors on your painting—adding a dark color to a light one on your canvas and blending them together. This will invariably produce an unattractive mess.

MEDIUMS AND THEIR USES

You can obtain many mediums from an art store. Many mixing variations for these mediums are described in technical books on painting. Most are unnecessary. They will not help you paint better. They demand a complicated procedure that helps little. Today, all reputable manufacturers make paint that is usable as it comes out of the tube. If you need to make the paint thinner, add turpentine. Some people are allergic to turpentine. If it irritates your hands or gives you a rash, don't use it. Instead, use mineral spirits, a petroleum derivative that has painting characteristics similar to turpentine. As you gain more painting experience, try using paint with a mixture of linseed oil and turpentine. But never use more than 50% linseed oil. Linseed oil makes the paint thicker. I use paint with a little turpentine or without a medium. Rarely do I find it necessary to use the linseed oil-and-turpentine mix. When you work with a dark color that *sinks*—seems to be a *dull gray* color—it is sometimes useful to revive it with *retouching varnish*. This brings back the color you have painted. Then you can paint new color accurately because you can see the old one clearly. Retouching varnish is useful as a temporary varnish for exhibitions. I advise you to use only these simple mediums.

Designing A Painting

Earlier, I discussed an excellent imaginative design on page 17, *Adam and Eve*. You may be attracted to paintings in which the most important element is the design. Many European artists painted this way. The work of Raphael is a good example.

Certain types of artistic design develop into stereotypes. Design is based on taste. It may be taste raised to a high level—a major branch of art—but it is difficult to learn design except by studying paintings and reading. You can also learn about design from Nature and by criticizing your own paintings. The study of design is helpful but should come later in your development.

Examine the geometric spirals in seashells and the way flower petals seem to complement each other. Observe how one part of a landscape leads you on to another. You will begin to see a certain *order*—an arrangement of balancing shapes and forms. Design is inherent in Nature.

As you study, you may notice that one group of shapes pleases you, while another does not. In art it is better to paint what you like. You may learn to

like curving shapes that flow into one another, or sharp, angular forms or a variety or shapes.

A good design is one that tells the story you want and makes the viewer understand what you want to portray. This doesn't refer only to grand subjects. I am referring to small things: the shining silver trunk of a birch tree, or the warm light that seems to embrace a piece of cloth and the apple on it.

Think of good design as the visually pleasing placement of objects in your painting.

These are some of the common mediums used with oil paints. They are retouching varnish, linseed oil and turpentine substitute. Retouching varnish makes colors appear fresh and bright in a painting. Linseed oil thickens paint. Turpentine—or a substitute, such as mineral spirits—thins the pigment.

Warm And Cool Colors

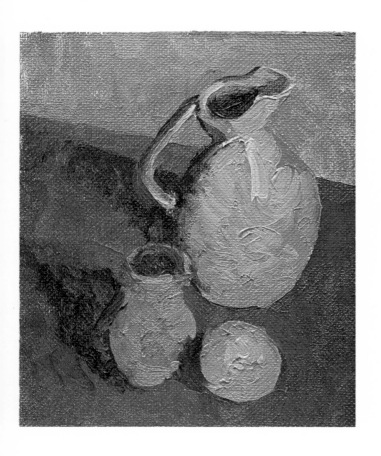

If you think of warm colors as going toward red and cool colors as going toward blue, you will have a good start toward understanding color temperature.

I suggested on page 20 that there were three questions you should ask when mixing colors on your palette: What is the hue of the object? What is its relative color value? What is its relative color warmth or coolness?

When painting, you should limit your objective. Try to convey one thing well. Don't try to make everything perfect. If you can learn about one thing at a time, you have a greater chance of solving a problem than if you try to sort out everything at once.

It would not be bad for you to paint the same still life three times. Each version can be devoted to one of the three questions about color—including its warmth and coolness.

Look at the two illustrations at left. The top one is brown, yellow and orange. The other is green, blue and gray. The top painting could be called warm, the bottom one cool.

Some of the colors are warmer or cooler than others in each painting. The yellow jug is not as warm as the orange. But the orange—although it is the most *intense* color—is not as warm as the cloth on which it sits. The cloth is much redder.

Which is the coolest color in this painting? It is the right side of the small jug, which is a bluish red.

In the bottom painting, the cloth is not as cool as the blue glass. Is the blue glass cooler than the green bottle? I think it is, because there seems to be a reddish cast in the green. The apple is certainly warmer. The warmest color is the dirty wall at the back. If you transferred this wall to the top painting it would be the coolest color there.

It is possible to paint the same subject twice so that each picture looks accurate. One painting can be warm and the other cool. It will depend on the emphasis you place on certain colors. It is helpful to study side by side all the pictures you have painted. Try to determine their warmth or coolness. It is likely they will be cool. Most painters tend to paint in cool colors in the beginning. If this is so in your case, make sure you add more warm colors in your next picture. A good exercise is to set up two simple still-life studies. Make one predominantly warm and one predominantly cool.

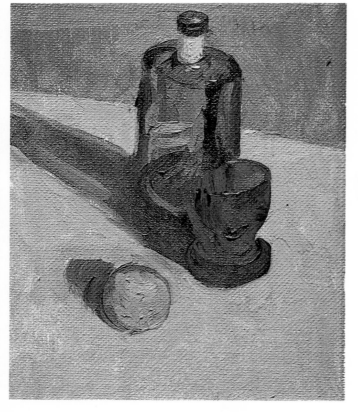

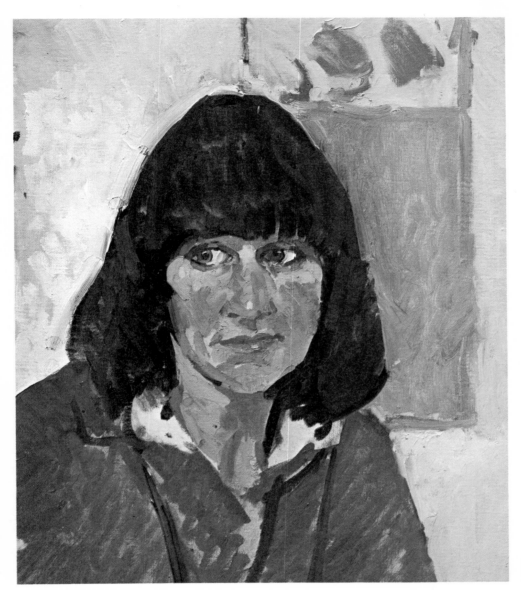

Lady in Richmond,
18x22".

Sometimes you can use cool and warm colors together for contrast. I had fun with the quick sketch, *Lady in Richmond,* above. The red of her jacket is intense and warm. Her cheeks are also warm. The blue in the background has a lot of red in it. Even the dark hair is a warm black.

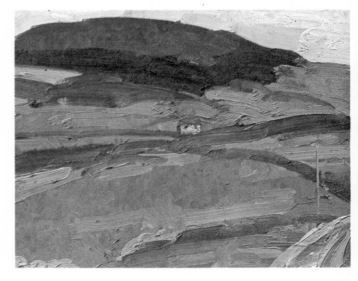

Irish Landscape, 7-1/2x5". The warm-colored roof contrasts with the cool-colored surroundings. The viewer's eye is drawn immediately to the reddish object.

31

Notes On Details

For some reason, almost every beginner thinks he must try to simplify what is in front of him. He thinks it is essential not to copy what he sees. The result is that he simplifies things in the most obvious way, so his picture looks dull. Small areas of detail control the large form. Compare this idea to the human body. The combination of wrist, elbow and shoulder determines what the forearm and upper arm can do. If these individual parts are well related, the whole arm will work. This relationship of small, individual parts to the whole is present in Nature. Train yourself to observe this phenomenon. In art, the relationship of parts to the whole is known as *harmony* and *order*.

It is usually better to paint most of the details you see. Try to relate the scale of the detail to the scale of your painting. You may paint a tree with many leaves, but you are working on a small board. Your trees are not large in the painting. The leaves you see, if you paint them in scale, will be smaller than a pin head. In such a small painting, you would have to sacrifice the details.

At left are three examples of details that are painted incorrectly and in the wrong scale. The top painting shows the bars of windows. Most painters forget that the top half is not in the same plane as the bottom half in this type of sash window. The top half is set *behind* the bottom if you are inside or vice versa if you are outside. I have painted a simple window to show how this appears where the top and bottom join.

The center painting illustrates two different types of bricklaying. Notice the different brick positions. The cement is a lighter color than the bricks—rarely will it be darker. Each brick varies. If you paint a brick house, don't try to indicate the bricks unless you sort out the particular brick-bonding pattern. It is better to describe the general color of the wall and not indicate bricks individually, unless the painting is unusually large.

The bottom painting shows a tile roof. The roof extends beyond the wall and is dark below the last row of tiles before you reach the gutter. Notice the size of each tile in relation to the size of the roof. Attention to details such as these will improve your painting. Always remember the relative scale of your painting.

Varnishing Paintings

By now you may have completed a number of pictures. They may be similar to those I demonstrated earlier or perhaps they are your own. Remember that you are a beginner. In a sense, *I hope you will always remain so*. The secret in art is to come to it fresh, as if the subject were new to you and you had never painted before. Everyone talks of looking with an innocent eye. What that statement means for you is to learn to recapture the intensity of observation you had when you painted your first study.

If you examine the work you have done, you may see that it has become *patchy*—dull in some areas, shiny in others. It may have *sunk*—the color may be grayer and seem lifeless. Don't despair. This is the normal way paintings dry, and it can be corrected by *varnishing*. Varnish will restore colors to their original brilliance. A coat of varnish will also protect your work from atmospheric impurities, such as sulfur. Don't be impatient. You must wait at least nine months for an oil painting to dry properly. If you want a painting to look its best for a special occasion, apply retouching varnish as a temporary measure. The method is the same as for a final varnish, but do not first wash the picture.

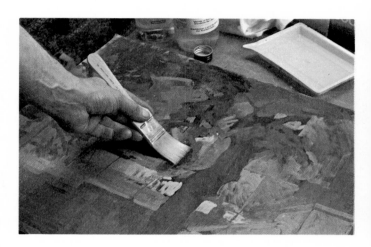

PREPARATION FOR FINAL VARNISHING

Make sure your canvas is taut by hammering the wedges at the back. Lay your board or canvas down on the table. Then wash it with cotton. Liquid soap and water is best. Don't use a liquid that contains ammonia. Distilled water is ideal. Squeeze out the cotton so you don't put a lot of water on the painting.

The purpose of washing is to remove the greasy, sulfurous dirt that has accumulated on the painting. You will be surprised how much there is. Then wipe the painting with cotton dampened with clean water. Be sure to remove all traces of soap. Dry the painting with more cotton. Finally, with the palm of your hand, rub off any cotton fibers that are caught in lumps of paint. Let the painting dry, leaning against the wall, facing inward.

VARNISHING

On the next day, lay the painting flat on a table. Examine it again to make sure it is free of cotton fibers—especially at the edges. Then varnish it. Be careful to brush in the varnish well. Artists' clear picture varnish is the most common type to use. If your picture is small, you can cover the whole surface with one brushful of varnish. If it is a larger picture, start in one corner and finish that area. The photograph above shows how I have varnished one square section. Then, apply the varnish in another square, leaving a little distance from the edge you have just finished. Brush the two edges together to ensure that the varnish is not too thick where it joins.

The secret of the process is to have the same amount of varnish on the brush each time—and not too much of it. Let the painting lie flat for at least 10 minutes so the varnish won't run down. Finally, lean it against a wall to dry, facing inward.

If you don't want the painting too glossy, use mat varnish. I prefer to put this on top of an ordinary varnish.

FINAL INSPECTION

Varnish can take one or two days to dry, depending on the weather. Examine the painting to see if the varnish is even and preferably not too shiny. Test for dryness by touching the picture's edge to see if it is tacky. At last, you can frame the painting and hang it for viewing.

Landscapes

Landscape Painting In One Session

I want to show you several stages in this demonstration so you can follow the painting from beginning to end. I have chosen a landscape because everyone wants to paint the countryside at some time or other. For many, the outdoors is the starting point of their interest in painting.

Distant Hills is a simple landscape. There are no difficult details to draw. You could handle the painting in many ways. The different stages of the painting were not clearly defined, but the ones pictured have been chosen to make a point. The painting actually should be called a sketch. It was done on location in one sitting that lasted about three hours.

THE DRAWING

Ultramarine blue and turpentine were used for the initial drawing on a white board, as shown at the top on the opposite page. I prefer to draw with blue rather than raw umber when painting landscapes on location. I do this because the color often is part of the landscape.

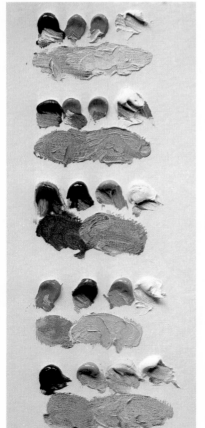

Sky

Distant hills

Nearby trees

Brown fields

Green fields

I drew in the horizon line and the base of the large central hill. Then I began to work out the lines of the trees as they came toward me. Next, I determined the width of the horizontal fields. I put a thinned layer of paint over the distant hill and worked in masses rather than lines. This practice helped establish the main areas of trees and darker values. I began to get the sense of space of the misty landscape onto the board. I wanted to capture the diffused sunlight coming through the clouds. The areas within the light changed often. It became more a task of establishing the general atmosphere and painting a few key shapes, rather than painting details. The drawing was purposely done loosely to save time.

MIXING COLORS

To repeat my earlier advice: *Mix colors and think through the color scheme on your palette. Apply the results of your thoughts on your canvas or board.*

It is always worthwhile to be painstaking when mixing colors. On the bottom of page 37 you can see the palette I used. It shows the order in which I mixed colors. You can see some of the mixtures I used in the illustration at left. They did not give me all the colors in the painting, but they gave me the range I needed to paint. The other colors are variations of these. At the top of the illustration is the color I mixed for the sky. The mixture for the lighter area in the top-center of the sky is not illustrated. For that, I used white and yellow ochre, with touches of ultramarine blue and cadmium red.

I knew I would start to paint where the sky and distant hills meet, carefully relating these shapes and colors. I mixed paint for the distant hills next. I paid special attention to the differences between the warm and cool colors. All these colors are pale, so I turned to the darkest colors, the nearby trees. Then I made sure I had the correct color for the brown fields. Note that the dark mixture in the illustration was too dark and had to be lightened. Finally, I mixed the green fields, but you can see in the painting that these greens were altered later.

First Stage—The first color I applied was the darker part of the distant hills, against the sky. I painted over the hill color with the sky color to get the shape correct. The blue drawing shows through in several places. Then I moved to the foreground, applying blocks of color against each other. I attempted to get them in the right place. I did not try to finish any area. In this stage, I was trying to put down the series of "thoughts" I had when I was mixing and planning.

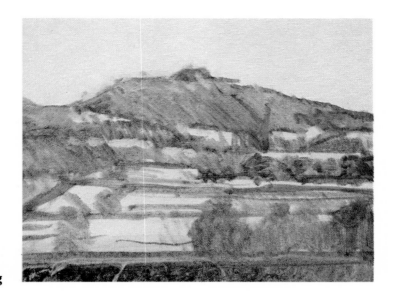

The drawing

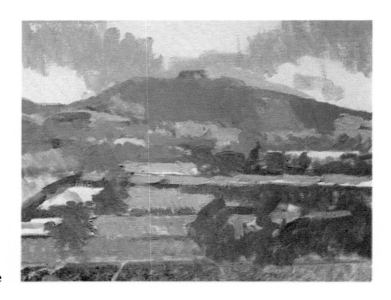

First stage

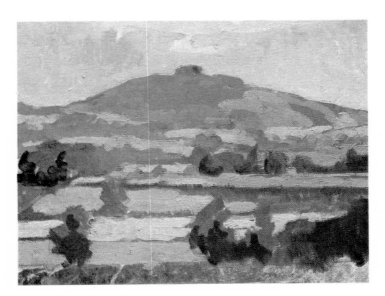

Second stage

Above and right: Details of finished painting.

Second Stage—The most obvious difference between the first and second stages is that the sky was developed further. It appears much lighter. I painted the areas I had not touched. Colors of previous shapes appear lighter now that the board is covered with paint. This is true even though they were not altered. Then I developed the appearance of distance. Look beyond the row of green trees in the middle distance on the right. You can see I worked a lot at the base of the hill.

I introduced some pinkish blues and modified the dark colors on the hill. Then I worked on the fields, lightening the greens and changing the brown field's color. Each tree or field began to take better shape as each touch of paint was added.

Final Stage—The clump of trees on top of the hill was painted. I put some lighter touches into the sky. More paint was applied to the distant hills, and all the trees were modified. I spent most of the time in this stage working out colors and shapes at the base of the hills. The subtle changes—a slight change of color, not value—were difficult to see in the bright light that existed. Small changes such as these can only be worked out in one place—on your palette. I wear a hat with a brim to shade my eyes when working outside in bright light. I hold my palette at an angle so it does not reflect light.

On the opposite page, you can see my palette as it was when I mixed all my colors. Remember that I

am left-handed. If you are right-handed, hold the book up to a mirror and you will see the colors as you ought to arrange them. By the time I finished painting, the palette was not so tidy.

At the top of this page are two details from the finished painting. The left one shows how the house blends into the surroundings. You don't notice it at first. Compare earlier stages with the detail on the right. You can see how I changed masses of colors into a recognizable group of trees and fields. This is what I mean by *drawing*. The term does not mean a linear outline that is filled in with paint.

Look at the final painting. I went over it in the final stage, slightly changing everything. This practice is not arbitrary. It's a useful way to make sure each part is painted in relation to other parts. Remember that this picture was painted on location in one sitting. I cared most about the illusion of distance and the misty light. The last few touches—changing the hill and modifying the light below the hill—mattered very much. When you do this kind of sketch, always try to give yourself time at the end to make minor corrections all over. Hurry at the beginning. Paint as if there is no time at all. Leave yourself time to think about the whole. But don't try to repaint everything. Decide if a touch of paint will help, not so much to complete a detail but to express the idea more clearly.

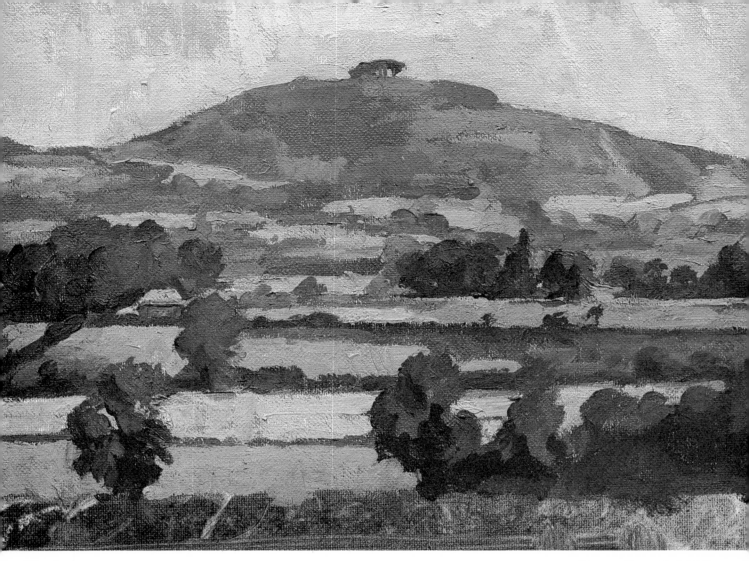

Final stage

The board was too large for the painting above, so I put raw umber at the bottom to eliminate glare from the white board. This section was cut off when the painting was dry.

Distant Hills, 12x8-3/4''.

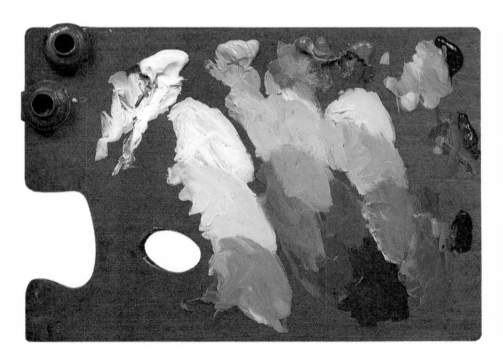

My palette had this look when I mixed colors for the painting **Distant Hills.**

Landscape Painting In Several Sessions

The previous demonstration was concerned with painting a landscape in one session on location. Now I will discuss painting a landscape in several sessions. *The Beehive* was painted in four days. I started at 3:45 each afternoon. I made corrections when I got the picture back home where I could see it without distractions. Each session lasted approximately 2-1/2 hours. It wasn't possible to photograph the painting while it was being painted. The illustrations on these pages are reconstructions showing the painted stages.

THE DRAWING

The painting was done on a reddish brown background. The drawing was done with ultramarine blue, as shown below. The main interest of the painting centers on the tree in the left foreground, the field beyond and the hedges on the right. I was concerned about how the movement of the hedges encloses the foreground. I went over the hedges several times in the drawing stage. I used a fairly wide brush because I wanted to work out the big shapes rather than paint details. At the end of the first session, I blocked in the sky area quickly with flake white.

The drawing stage allowed me to put things down in the right place and helped me think about the best way to paint the picture. I chose to paint this scene because I liked what I saw. But I was concerned with what I put in the painting. I didn't want to include all the endless lovely landscape surrounding me. I wanted to concentrate on the main subject. That's why there is no more sky showing in the painting. The hills rose up in the distance, so I was more aware of the landscape than the sky. When you are faced with the decision of what to paint, remember this: It is better to make up your mind what you want in a painting before you start.

Many painters speak of *artistic license*. They contend that some subjects would look better if the artist moved a tree, building or other object to a different location in the painting. I believe this is false advice. Don't alter what is in front of you. Nature is lovely. It is your business as a painter to understand Nature. You must find the design in what you see and not try to improve on it. If you move something, you leave a gap that is not easy to fill. It is important that you be able to judge one part of the painting against another. It is difficult to make that judgment if you introduce a new feature.

First Stage—I spent a long time mixing the colors on the second day. This reconstruction shows the

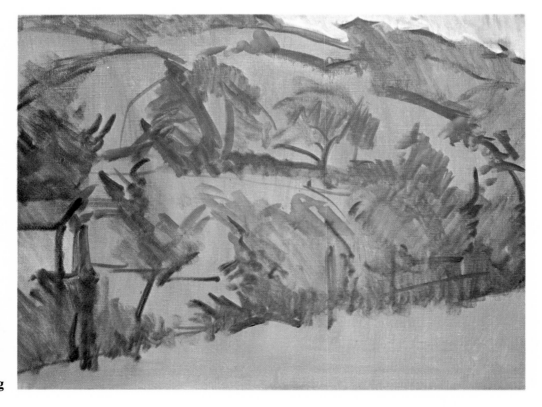

The drawing

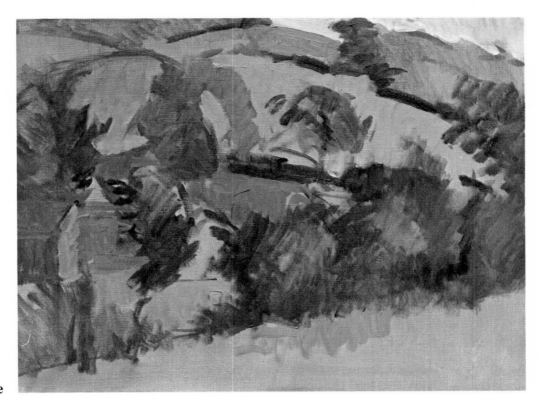

First stage

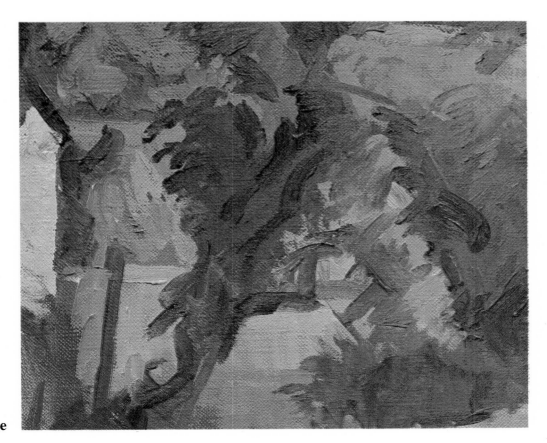

**Detail of
second stage**

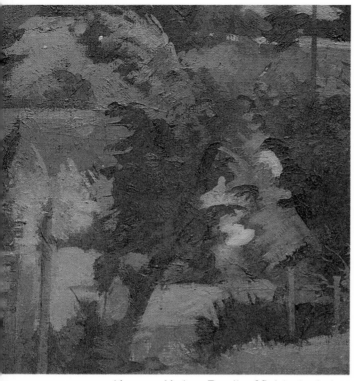

Above and below: Details of finished painting.

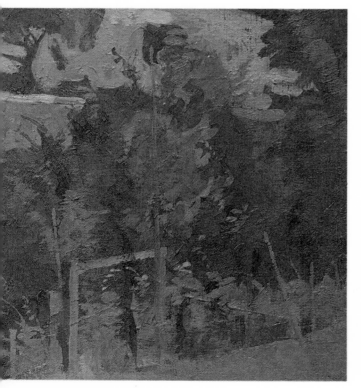

stage I reached by the end of the day. I didn't progress far, but I was mainly interested in mixing each color as I wanted and putting it down freely. Compare this with the final painting. It is clear I was much freer in the early stages than I was in the final version. I was most interested in a special area of the painting. The hedge demanded working in great detail so the painting inevitably became more rigid in design.

Don't be afraid of detail. Paint as meticulously as you can. Try to look at every blade of grass, every twig and every branch, but always in relation to the scale in which you are working.

The building on the left in the finished painting is a grand antique medieval beehive from France. Compare the first stage with the detail of the second stage and the final painting. You can see that the right side of the building changes color and value through the different stages. It is a dull gray in the first stage, a brighter yellow in the second stage and brighter still in the final stage. The light can change over four days—it did dramatically while I worked on this stage. It is always better to alter what you have painted if you think it is necessary, unless you believe you have painted an object perfectly. In this painting, it was not until the last day that I realized it would be helpful if the building were light-colored.

Constant light changes should be thought of as a challenge, not a nuisance. Ask yourself: Is the subject better in a bright light or in a dull glow? In a bright light I can see many details that are hidden in less light. Should I paint them? The distant fields seem a brilliant brown at one moment, and a dull grayish green the next. Which is correct? All possible variations of the answer may be right in a picture, but they won't all be correct at the same time.

It is fun to choose color schemes. Painting is not a mechanical exercise in which you follow a set pattern. It's an adventure in which you turn in many different directions. It would be instructive for you to compare each point in the first stage with the final version. The brown field in the center background becomes much cooler in the final version. The field below it becomes bluer and lighter.

Second Stage—I have shown a detail of this stage so you can clearly see what I was doing. It is useful to think of *every* brushstroke as a new idea, requiring you to modify your first mixtures. Has the new brushstroke a little more blue or red—is it warmer or cooler—than your original mixture? Make a decision to go one way or another. The near tree and hedge are painted too blue. As I went on, I noticed they had more interesting greens in them.

By now you have probably realized that correct mixing of colors is difficult. Despite the difficulty,

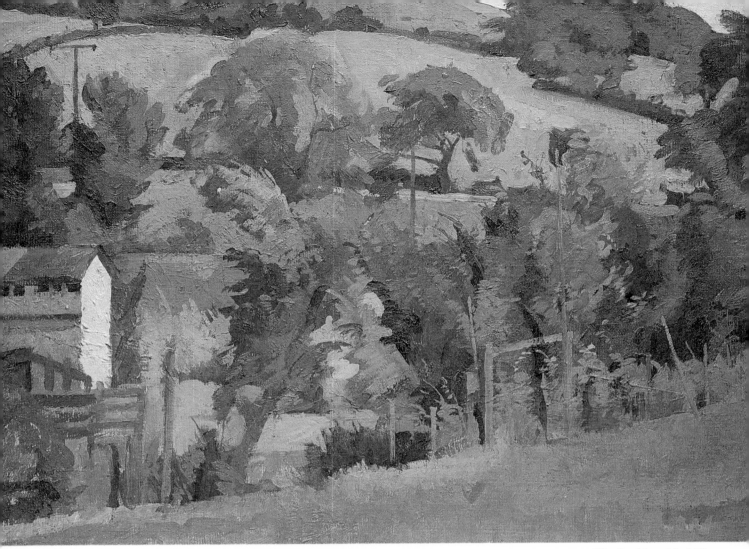

Final stage

The Beehive, 18x14''.
Collection of Chris O'Neill.

mixing is where you should devote a lot of effort. Always be willing to change anything. Try to put down each color as correctly as you can.

Final Stage—In the detail of this stage at the top of the opposite page, you can see how I worked hard on the tree. It changed color many times. My aim was to distinguish the groups of leaves. I carefully watched where the darker accents in the tree appeared. It is easy to lose your place when working unless you concentrate on a particular spot for each brushstroke.

The post-and-rail fences shown in the lower left photograph on the opposite page caused me much trouble. I found it difficult to see what was happening. As a key, I used the tall post between the beehive and the main tree shown above. This post caught the light. The others were in shadow.

Always try to make each picture you paint a little more difficult for yourself. Don't be satisfied with learning how to do it one way.

I painted the large trees as I went along. You can see how I drew the branches of the tree by painting the field. In the final painting I have corrected these. Such details should not be painted too quickly. It is more helpful to move from one area to another just before you solve final problems with each one. Postpone the last brushstroke. Paint elsewhere, then come back with a fresh eye and see what needs to be done.

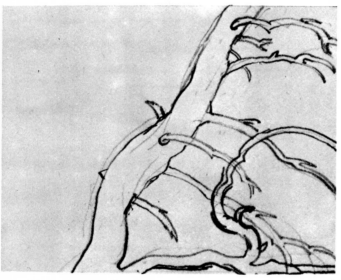

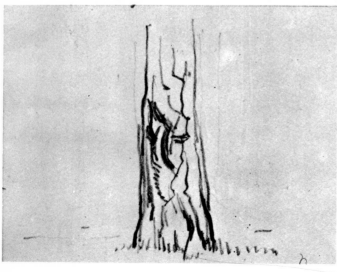

Notes On Trees

The illustrations on these pages were drawn with a 2B pencil. You need information about your subject when you paint. These are the small notes you can make when looking at trees in the winter. I was trying to make quick tree sketchs that I could use in later paintings. My point is, be a good observer. Trees are something you can look at easily. Such sketches will help you remember small differences in the way trees look.

There are certain basic things to look for when painting trees.

First, study the silhouette. If you know the characteristic shape of a tree, you can recognize one from a distance. But be careful, because trees do not always look the same. I remember painting some tall willows, although we usually think of them as being short. I remember searching in vain for an oak that grew in a semicircle, as I expected it to be. Most oaks seemed to be old and growing in a peculiar shape.

Second, look at how the trunk of a tree enters the ground. The two you see here—the pine at lower left and the walnut at lower right on the opposite page—enter the ground differently. These are two extremes. Most trees do not expand like the walnut, but enter the ground more like the pine does.

Third, look at the framework of branches and see how the tree grows. This is difficult in summer, but you can see what happens if you walk under the branches. Study how the branches split off from the main trunk. The top left sketch is a pear tree. There are four major divisions from the main trunk at the same point. This is unusual and is generally caused by heavy pruning. The center left sketch shows a fir where all branches grow from one side. A strong prevailing wind can cause such characteristics. Branches will appear only on a sheltered side.

Fir trees have a main trunk. Branches spring out of this trunk and both become thinner as the tree grows higher. The pear tree divides more equally, although one branch will be dominant. The top sketch on page 43 is an old walnut. You can see how each time a branch divides, one is slightly thicker. Branches have been cut off the apple tree shown at center right. It seems to send out new branches at right angles. The pear tree seems to grow upward. Pay special attention to how a branch joins the trunk.

There is an old idea—perhaps recorded first by Leonardo da Vinci—that the trunk volume equals the volume of all twigs at the end of every branch.

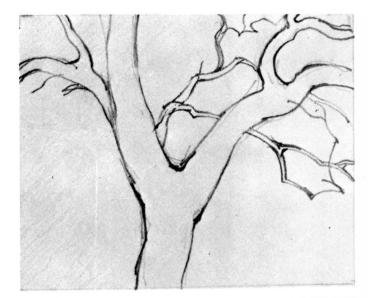

This belief was based on the fact that when a branch divides, the two new branches equal the old one in volume. Experts say that this has not been proven, but it is a useful guideline for artists to follow. Every time a branch divides, the two new branches will be smaller. One will be larger than its companion.

How can you paint the framework of a tree in summer when it is covered with leaves? At times you will see branches through the leaves. Make sure the branches you paint agree in scale with the way that tree has developed. British painter John Constable found it helpful to remove some branches of a nearby tree to see the structure. For most people, this would be impractical and difficult. This section is meant to show you how important detailed studies can be.

There are two other important considerations when painting trees. Try to think of a tree as an umbrella with lots of holes in it. The ribs are the tree branches. You can see what is on the other side through the holes. Think of the way the direction of light from the sun makes one side of the tree light and the other dark. Because of spaces between leaves, you can see dark areas on the light side and light areas on the dark side.

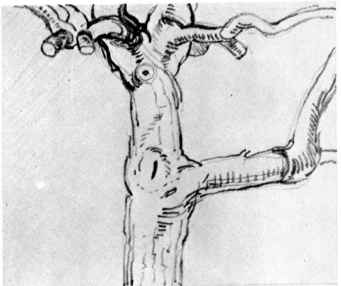

Finally, look at the way leaves group themselves. Each type of tree is different. When painting, notice how these groups form patterns that are characteristic of that type of tree.

Much of this visual training can be done by making sketches like those shown here. The more you add to your store of knowledge, the better. Make sketches of branches in the winter, even though your main interest may be in painting trees during summer.

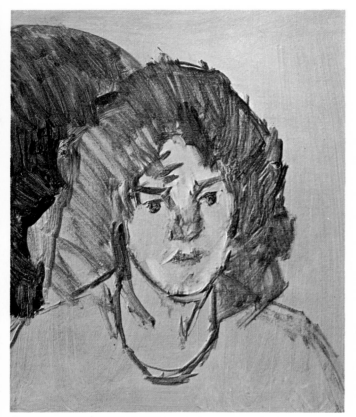

The drawing

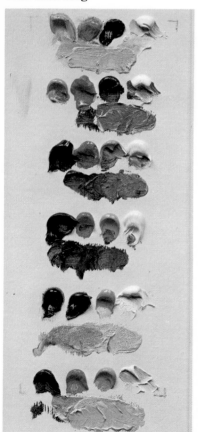

Light face

Cheek

Hair

Chair

Wall behind

T-shirt

Portraits

A Portrait Sketch

The way you paint a subject is determined only by your commitment to it. You don't approach a landscape any differently than a figure. There is no special way of starting. Some painters shy away from subjects for which they have little sympathy. I learn as much about painting portraits when I paint a landscape as I do when I make a special portrait study. The colors I use are almost complementary—cool reds in portraits and warm greens in landscapes. Because of these colors, I learn a lot about painting landscapes when painting portraits. I usually paint landscapes outside and portraits in the studio.

With landscapes, I draw on the canvas in blue. With portraits, I use raw umber. I have painted many portraits in which I first drew in blue and landscapes in which I drew in raw umber. But this latter method does not usually work as well, because the portrait's design has to be worked out carefully. I'll discuss this more later. The painting *Judith* on page 47 was done in one day. It is a sketch.

THE DRAWING

The whiteness of a board or canvas can be a deterrent to beginning. This painting was done on canvas in the studio. Usually I stain the canvas with raw umber diluted by turpentine. I put it on the canvas loosely and quickly with a large brush. I wipe over it with a rag to make the value even and to fill in gaps I have left. Some painters prefer to leave this raw umber wash more open and varied in value.

I started drawing by indicating the top of the head with a line. Then I went to the right edge of the hair. I drew a line down the center, where the part would be, to the top-center of the forehead. Then I drew a line on the right down the edge of the face onto the chin and up the left side of the face. I quickly drew in the mass of hair with a big brush. At this point, it was possible to see whether or not the head was in the right place on the canvas. If not, it could be wiped out with a rag and turpentine and started again.

The dark of the eyes was done with two coarse brushstrokes, followed by the eyebrows, comparing the directions. Placing these established the scale of the head. I put in the line of the shoulders and the edge of the shirt around the neck. Then I came back to the right side of the face and corrected the cheekbone and edge of the face. I drew in the right side of the nose, then the left. Next I moved down to the mouth.

I put in the dark of the chair on the top left with a large brush. Then I corrected the top of the shoulders. I came back to the mouth, corrected its position and drew the line between the lips. The nose was not right, so I wiped out part of it with a rag and turpentine. Next I altered the line of the jaw on the left. I moved to the right side of the face and changed the edge of the cheekbone.

The purpose of all this drawing and correcting was to get the head correctly placed on the canvas. It was first necessary to make the scale correct in relation to the size of the canvas and to place the features. This is a quick sketch. I wanted to get on with the painting. The drawing stage took about 20 minutes.

MIXING COLORS

You will see that I spent as long on the first stage as I did on the drawing. Yet I touched the canvas only a little. Almost all the time was spent mixing colors on the palette. I used the basic palette colors plus raw umber. On my palette, in order, were flake white, yellow ochre, cadmium red, viridian, cobalt blue—instead of ultramarine blue—raw umber and ivory-black. I mixed the lightest color of the face from yellow ochre, cadmium red, viridian and white. I used the same colors on the cheek. I also tried a mixture using cobalt blue instead of viridian. The hair was raw umber, cadmium red, yellow ochre and white. For the chair I used the same series of colors in different proportions. The background was from the same mixture as the chair, but without the red. I also added ivory-black to the mixture. I used cobalt blue, cadmium red, yellow ochre and white for the shirt.

First Stage—I used a different brush for every value of every color. I mixed all the basic colors I was going to use. I didn't bother with the mouth color or the slight redness of the cheek. I put a touch of each color on the canvas, starting with the forehead. The forehead was too light in this stage. Then I moved to the hair, the eyes and so on. I attempted to get each touch of paint in the right place. Every main color was put down, sometimes with just one brushstroke. This stage took about 20 minutes.

Second Stage—I worked more on everything for the next 30 minutes. I started to draw the eyes better, but I didn't properly paint the corners nearest the nose. More paint was applied everywhere. The drawing of the nose was still not quite right, and the corners of the mouth needed some attention.

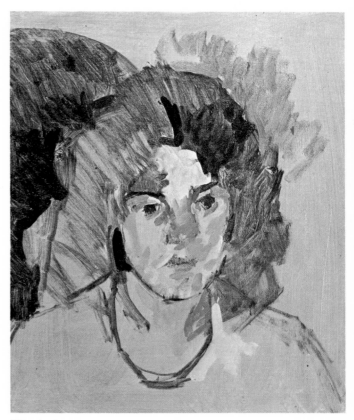

First stage

Second stage

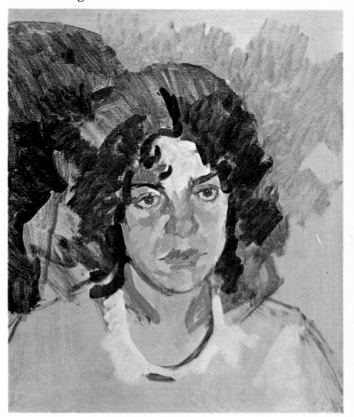

45

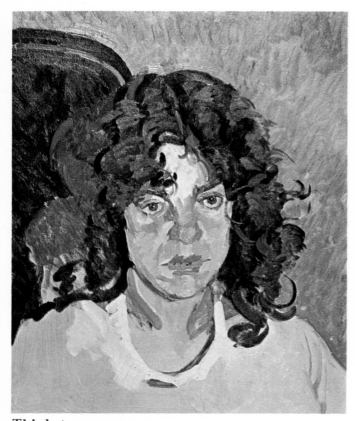

Third stage

Third Stage

Third Stage—Never work on one area to completion at the expense of the rest of the painting. At this stage I was more concerned with getting the surroundings onto the canvas than improving the face. It's a mistake to think you can fill in the chair or paint the background while the model takes a break. You need her there so you can choose the right colors next to her face. I painted the colors of the hair and the shirt. Always try several times with an object like a shirt. Don't mix the color and paint it completely. At every stage, I worked on the shirt, slightly modifying the value or color until I got it to my satisfaction. At the end of this stage, I corrected the left side of the face and then painted the chair.

I try to put every brushstroke in the right place, but I immediately make an adjustment with another stroke of paint beside or on top of it. I want to emphasize one point: Don't use too much medium. You can adjust a brushstroke more easily if you limit the amount of medium you use. This stage took about 30 minutes.

Final Stage—The shirt was completed and the mouth corrected by this stage. Most people worry too much about likeness. From these stages you can see how the likeness changes. This is achieved by small alterations. A touch to the edge of the mouth or a corner of the eye or nose can make a great difference. Try to get the basic structure right. Make likeness corrections at the end of the sitting. In this case, my daughter Judith was growing tired and pensive. It would have been possible to make her appear to smile by altering the corners of her mouth. But I was more interested in portraying her character than painting her at her prettiest.

This final stage took about 30 minutes. All the sittings lasted over two hours. Judith had rests at the end of each stage. It would have been possible to paint longer, but don't overdo each sitting when painting a friend. I can see alterations I would like to make when I study the final painting. The final judgment on quitting must be made with the painting in front of you. I found it helpful to stop here and leave this painting alone. Sometimes I like to get the sitter back to make an adjustment at a later date.

Final stage
Judith, 16x20'', right.

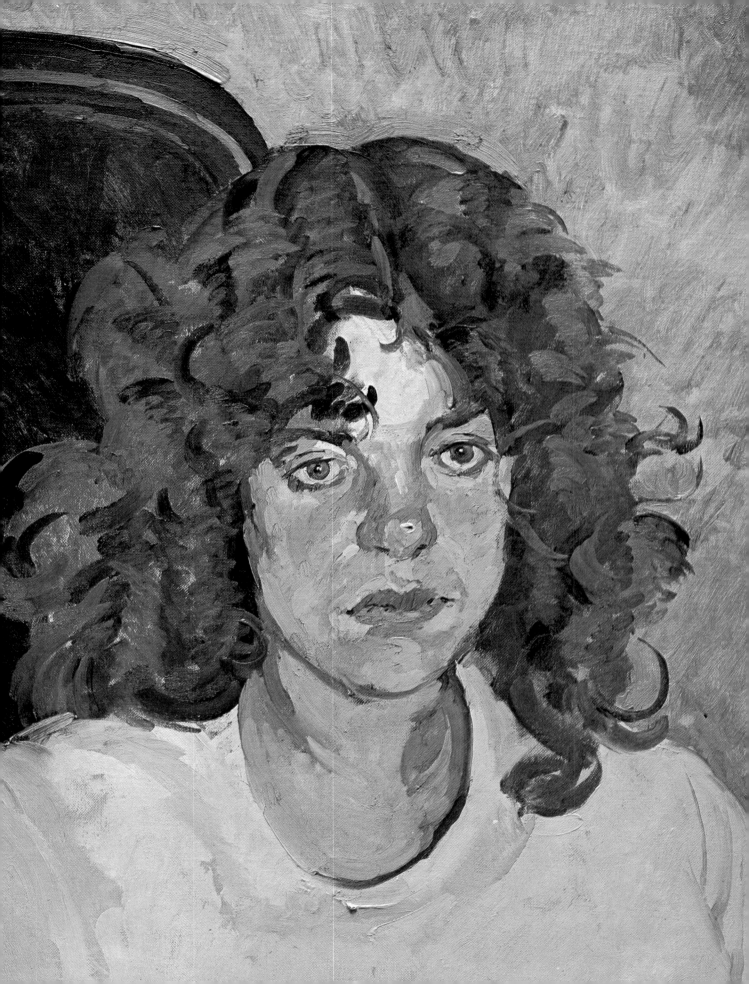

Detail from **Virginia and Sophie**.

Sketch of **Virginia and Sophie**, 53x42". Collection of Jill de Brant.

Advanced Portraits

The design in the sketch of *Judith* could be described as a *pleasing placement of shapes*.

Virginia and Sophie is a large, more considered painting that measures 53x42". The completed painting is shown on page 5. The design had to be worked out carefully. I made a number of pencil studies to give me a rough idea of the size I would like to paint.

The next step was the sketch shown below. I used ordinary brown wrapping paper, charcoal and white chalk. I drew rapidly in the same size I wanted to paint. This helped me to plan shapes clearly on the canvas. The lines ruled over the sketch were duplicated on the canvas. These enabled me to copy the sketch quickly with raw umber and turpentine. This can be done without the model.

All the pencil sketches I made of *Edwina*—shown on the opposite page—were done with the idea of painting a conventional upright portrait. Then I noticed her reflection in a mirror behind her. I immediately started a sketch in the scale I want-

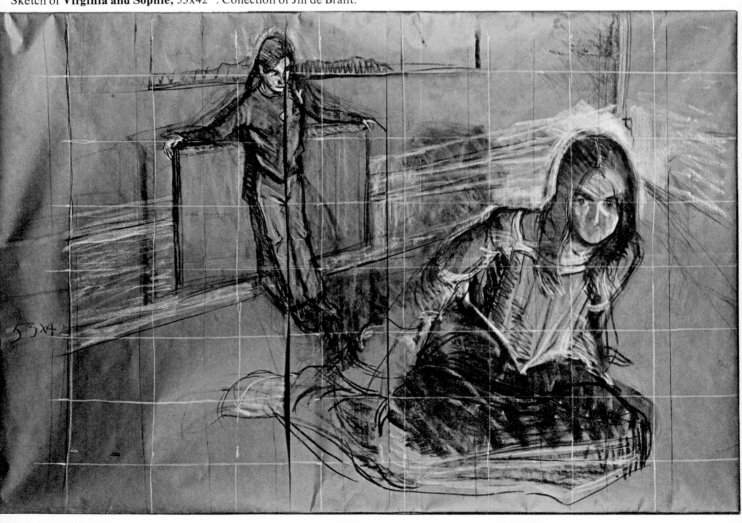

Sketch of **Edwina**.

ed—40x30''. The chair and its reflection made a lovely shape in the center of the painting. I was concerned about putting them in the correct place.

Compare this sketch with the final painting on page 51. The central figure is slightly smaller in the finished work. The hands are not as near the bottom of the painting. I don't think of the sketch as a finished product that I will copy. Rather, it's a step toward a picture that I will *vary* when I am painting. In the sketch of *Virginia and Sophie,* I have not completed the right side of the painting at all. In *Edwina,* the easel in the mirror was not included.

Use sketches as aids to think about what you will paint. They can help you get the drawing correct. Sketches are a way of sorting out ideas. Sketches seem to take a lot of time, but they actually save time in the long run.

I stop working on a sketch as soon as I have created the main design. I don't use the sketch as a means of studying areas I know will be difficult, such as hands. This method of working can be a real

help if you stick to these ideas. Don't think the sketch must be correct in every way.

The detail of books on the opposite page is part of the painting *Virginia and Sophie.* When you look at the whole painting on page 5, you will notice only that there are titles on the books. Look closely at the detail. The titles are all relevant to the painting—where it was done and the date it was finished. I call this a *conceit.* I enjoy having a little private fun this way. When you sign your paintings, do it discreetly. Don't let your signature interrupt the idea or message you are creating. This is even more important in small paintings. You can see in the detail of the chair on page 50 where I signed *Edwina.*

When you paint a more complex portrait, try to make everything in it say a little more about the subject. I include the hands whenever I can because they say as much about the person as the face does. In too many distinguished portraits, the artist has painted hands from a different sitter. This is a bad practice.

Above and below: Details of the finished painting.

The idea of using the mirror in *Edwina* was to give two versions of the sitter at once: the gentleness of her portrait looking at you, contrasted with the straighter-backed version in the mirror. When I have an idea like this, I try to think of reasons why I should do it. This approach gave me another dress to paint that was slightly different in color.

I knew when I started the painting that the dress was going to be difficult. I had no idea how to paint it, but I was determined to do it in detail. I drew the figure in raw umber and put down the shape of the dress. I applied some of the darker blue strokes of paint, following the pattern as closely as I could. Then I began to paint some of the lighter areas. I noticed that the arm nearest the mirror was reflecting light. I painted this arm too dark at first but gradually lightened it.

I painted the dress in the mirror at the same time I was working on the main dress. This allowed me to watch carefully the changes of color and value between the two. I worked on the dress during several sittings. I sometimes corrected it after Edwina had left. This forced me to remember corrections I wanted to make but did not have time for when she was sitting.

I started with the head in the center. I worked on it a long time before I did much elsewhere. I established the color and value of the chair behind her head, but did nothing about the shape at this stage. I gradually began to work all over the painting. When you are painting a picture as complex as this, you may work on only one area and forget about the rest. This can cause you to paint that part in the wrong value. It is always wise to mix other colors on your palette before you start, *even if you don't intend to paint with them.* When mixing colors at the beginning of a session, I recall exactly what I was doing before and plan what I intend to do next. Beginners will find this practice invaluable. It is important to have the same set of colors on the palette each time. Otherwise, confusion will result. I test colors on the painting to see if they are correctly mixed.

In the early stages of a painting like *Edwina,* I don't paint on any part unless the sitter is present. It is too easy to paint wrong values. Later, it's possible to work on parts of the picture when the subject is not present. I painted the right arm of the chair while she was there, but the rest of it when she was not. I did some of the wall pattern on the right while she was there, but completed it when she was away. I always corrected such areas in the next sitting.

You can see in the detail of the chair that each button is different and carefully painted. I did not emphasize them. They had to be kept in a dark value but still add interest to that area. The curved wood in the center of the detail caused me a lot of

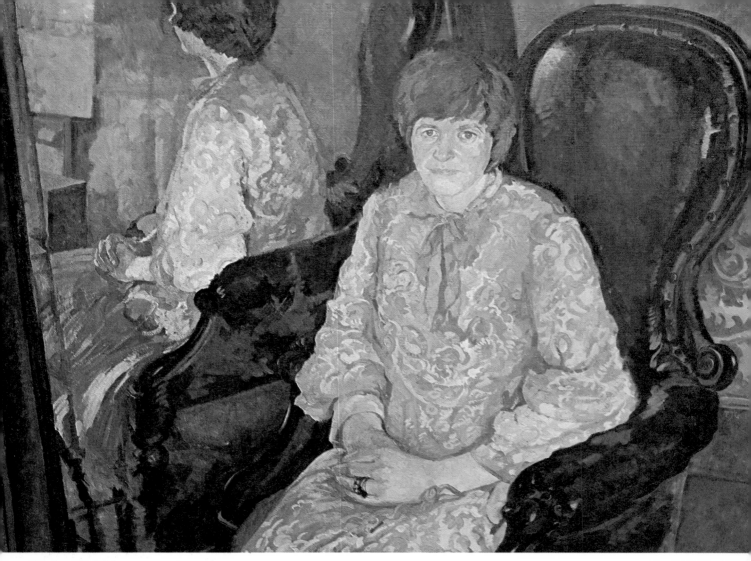

Edwina, 40x30''.
Collection of Gareth Evans.

trouble. I painted it well but in the wrong value at first. So I scraped it out and started again. This takes a lot of courage for a beginner, but it's worth the effort. Having done it once, you can do it more easily the next time. The determination to go to a lot of trouble has to be learned. As you develop as a painter, you will be even more painstaking in your work.

The detail of the hands in the mirror on the opposite page is shown because it was an area of special difficulty. I spent a long time mixing colors on the palette for the hands. I wanted the reflection to look right. There is something different about hands reflected in a mirror. I didn't try to paint the hands correctly at first. I repainted them during several sessions between working on other areas.

The reflection of the easel was changed many times. At one stage I painted it in more detail. But it became too important, and I had to omit the details. You may find this a helpful way to work. The right sleeve of the dress was painted in more detail over a number of sessions. I finally simplified it because it detracted from other areas I wanted to emphasize. Details can be lovely. Simplify something only when there is a good reason to do so.

Buildings

In this book I have tried to write about subjects that beginners like to paint. Everything is paintable, even a plain brick wall. But you will always like some subjects more than others. Whatever you enjoy painting, it is good to consider buildings as a subject. Even if your main interest is landscape, there will almost always be some buildings around.

I discussed some aspects of painting building details on page 32. Here are two more details you should study. Chimneys on the skyline can be a nice accent in a painting. Think of the way they alter the silhouette. Large masses of chimneys vary in shape, as shown at top left. I believe that television aerials have a similar effect on paintings. Telephone poles are even more useful in landscapes. They provide strong vertical contrasts against the horizontal countryside and the roundness of trees.

When you paint chimneys, don't make them too dark in value against the sky. They are dark or light accents, and it can be easy to overdo the value. They are small, but they will be too noticeable if the values are wrong.

A study of a typical London porch is shown below the chimneys. Both studies are reproduced the same size they were painted. On many occasions, they will be this size, or even smaller, in your paintings. Studies such as these are good training. They don't take long. When working on small areas, I believe it's easier to keep the entire area wet. Paint it all at once.

Note where I have corrected the darker strokes of paint by placing light colors close to them. When painting details, make sure the tops of windows and doors are square. Don't let them slope or look unfinished. Paint the darks first, then the lights. I used a mahlstick and a small brush for the detail paintings at left.

In the detail from *Sussex Landscape* on the opposite page, notice how I carefully painted the lower window. This is a detail from a larger painting. It was painted on location during two evenings. I like painting buildings and trees together this way. In the tree on the left you can see how several touches of the light building were painted on top of the tree. Lower down, the bushes were painted over the window. On the right, green leaves were painted on top of the orange building.

This is more freely painted with thicker paint than I used in the two building studies at left. In the studies, I eliminated almost all the brushstrokes. In

Sussex Landscape, I painted with definite brush-strokes. I used no medium except to clean the brushes occasionally.

Often it is the relative position of color of a building with a tree that makes a landscape exciting to paint. The orange-red I used for the building on the right works well against the tree. If you saw this painting in values only—in a *black-and-white* reproduction—the greenery in front would look only slightly darker than the orange-red building. The contrast between greenery and building is dramatic because of color, not because of value.

Red bricks against a green landscape don't always work well together. This is because the colors—when painted in the same strength or value—may cancel out each other. One authority on painting believes that more English landscape paintings are spoiled because of brick color than for any other reason. I think it is best when the color of buildings blends into the landscape. But judicious use of red—a small touch of it—can be dramatic.

Many artists like to paint an urban environment. It is a mistake to think you must paint only rolling hills and forests. The buildings in cities and villages are worth painting. Painters such as Camille Pissarro and Georges Seurat worked extensively with urban scenes.

At Home, Looking North, on page 55, was painted from an upstairs window at the back of my house during winter. The view no longer exists. Now there is a block of apartments. The bell tower has been obliterated. I wanted to paint the scene because I noticed that snowfall had changed the view—roofs that were dark suddenly became light. I always wanted to paint this view. I looked at it often, but never found a satisfactory way of approaching it, mainly because the roofs were too dark. But the snow changed that.

I disliked the building in the foreground. I thought it ridiculous that when erected it had to have the wooden shedlike structures to house water tanks. I wanted to make it look as dull as I believed it to be. I don't think I could have managed the

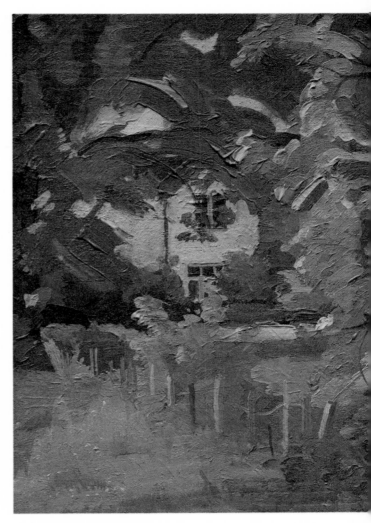

Detail of **Sussex Landscape,** 10x14''.

Above and below: Details of the finished painting.

painting without the interesting backgrounds behind the building.

You can make commentaries—however tough, however gentle—in painting. Not all art is about prettiness—think of Francisco Goya's horrors of war. For me, the dullness of the foreground of this painting makes the details farther back much more interesting.

An important thing to notice when painting on location is the design of Nature. Take advantage of what is given to you and don't alter it. The light green shapes on the front building's side were in just the right place to balance the pink curtains in the windows of the building behind. The bell tower was in the most prominent position it could be. The roofs were lighter than the sky, which helped direct attention to the gentle red of distant buildings. These placements were all natural. I didn't alter them.

The detail at top left shows two windows. The curtains were not always drawn the way you see them, but I noticed them like this one day when I was painting. Do alter your painting like this. Take advantage of a sudden change, and don't think of it as a nuisance.

The lower left detail shows buildings on the next street, seen through two large walls. On the near side of the street is the snow-laden roof of a black shed. Notice how I varied the way I used the paint. The large walls were painted smoothly and thinly. The shed roof was painted smoothly and thickly. When I first painted the roof and houses, they were carefully done, more like the walls. I wanted greater contrast, so I repainted them as you see them now.

Take advantage of the way you can vary oil paint. You can alter the whole meaning of a passage of paint by the way you put it on the canvas.

Look at the detail on the opposite page. The spiky, thin shape of the bell tower had to be just right. Such objects must be drawn carefully to be effective. Below and to the right in the detail is a dark red chimney with a lighter wall above it on the right. The main mass of houses in the distance is light red. I tried to create interest with all these reds together. I was concerned about warm colors throughout the

At Home, Looking North, 30x20''.

Below: Detail of the finished painting.

painting. All have been carefully measured toge-
ther—producing a warm, quiet painting.

I used the basic colors listed on page 14, plus aliza-
rin crimson, light red, raw umber and cobalt blue,
making 10 colors in all. This is more than I generally
use, but I wanted to make a clear difference between
reds in this painting. This was an occasion when it
was helpful to use a different brush for every value
of every color. At one time I had 20 brushes in my
hand. I took three days to complete the painting,
working from 10 a.m. until dark. This is not my
usual practice. But because I was looking north on a
winter day, the light hardly changed.

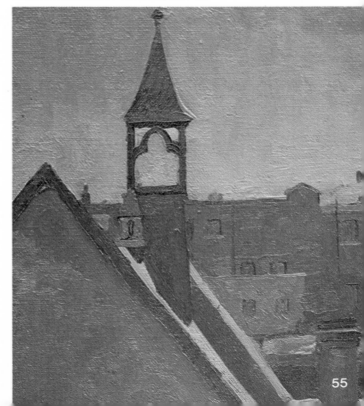

Reflections

Over the years, I have been fascinated by water. At first I enjoyed the contrast between object and reflection. I suppose my interest in mirrors is similar. I like the slight change of value. Reflections are slightly darker in value. When painting a reflection of the sky, be sure you paint the reflection and sky at the same time. It is easy in variable weather to paint a cloudy sky, then find by the time you paint the reflection that the sky is clear and blue. Then the sky and reflection won't match.

I have found interesting colors in reflections in hot climates. I gradually painted less of the object and concentrated more on the reflection. This enabled me to keep the colors brighter. *Collias Reflection* on the opposite page is an example of this type of painting. It's a reflection of a span of a large bridge.

I find it best to do a minimum of drawing in reflections. It helps me keep colors clear and bright. Below is the preliminary drawing for *Gozo Reflections,* shown finished on page 59. This drawing was done only to place shapes approximately. The drawing was made with a large brush, lots of turpentine and ultramarine blue. I put a wash of color only

where the colors would be darkest. In a hot climate, a drawing will dry rapidly. Even if you paint with more medium than usual, the paint should not disturb the drawing underneath. The drawing for *Bridge, Moor Park, Surrey*—shown finished on the opposite page—was made with thin blue lines. The day was cold, and I didn't think it would dry quickly so I kept the paint thin.

I usually prefer to do this type of painting on canvases or boards at least 20x16". I am preoccupied with details if I work on a smaller size. I have made studies of the sea and the sky that are smaller, although I find breaking waves difficult to paint on a small scale.

Painting reflections demands that you get relative values right. If you like reflections as much as I do, you will enjoy painting such subjects. Even if you don't, I recommend you try it to improve your appreciation and understanding of values.

Bridge, Moor Park, Surrey is a small painting, the type on which you can practice painting reflections. Note how the color of the bridge becomes darker and cooler in the reflection, while the sky does not. It is only slightly darker in value—I mixed sky and

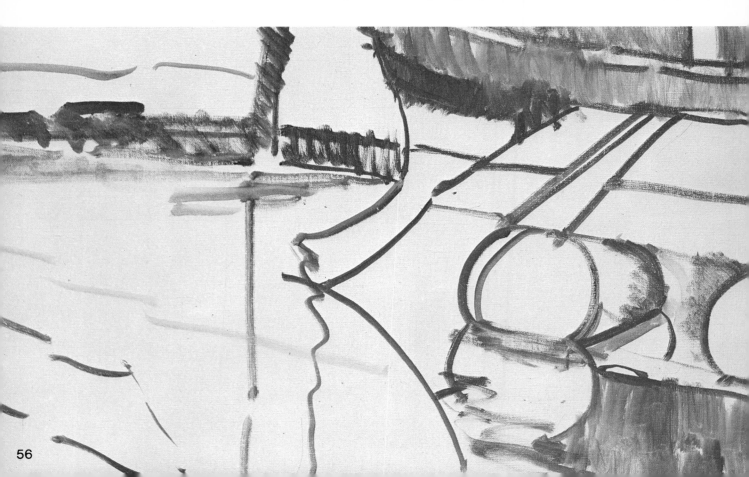

reflection color together. I used normal-size brushes and handled it no differently from paintings discussed earlier.

Compare this painting with *Collias Reflection,* which is larger and more loosely painted. The real secret of technique when painting loosely is to sit in your chair and paint at arm's length. Or you can stand if you prefer. Always use a loaded brush, and don't mix up your brushes. Always paint with the tip of your brush.

I prefer to paint reflections in one sitting. The time will vary from 2-1/2 to 4-1/2 hours. I lose my concentration if I work longer than this without a break.

Keep enough paint on your brush so you can work in large, single strokes. Sometimes a stroke can be quick and loose across a large area, but you must *not* go back over the same stroke. Put the stroke of paint down and leave it alone. Look on page 58 at the detail from *Collias Reflection.* You can see how I put down each stroke of paint. I altered the first strokes several times in the middle of the painting. But in the left-center area you can see several clear strokes of paint. All the work was done

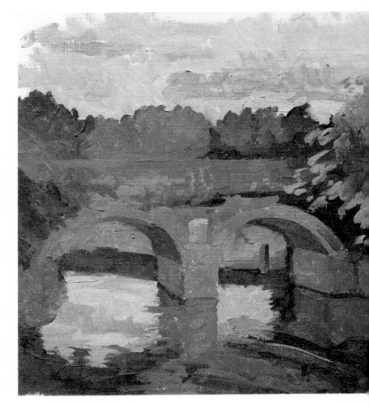

Bridge, Moor Park, Surrey, 9-1/2x10''

Collias Reflection, 20x16''.

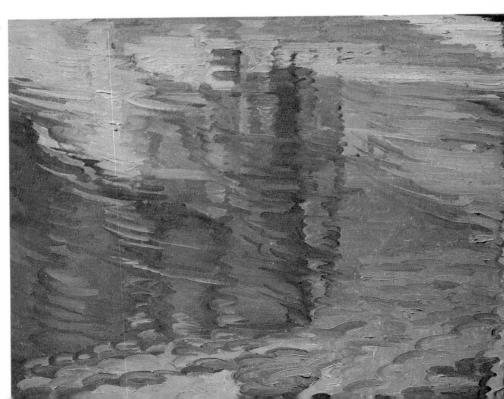

Initial drawing for
Gozo Reflections, left.

Detail of **Collias Reflection**.

like this. Some paint was altered as I went along with subsequent strokes. But the painting was done mainly by putting down lots of single brushstrokes.

I worked at all times with firm brushstrokes. I never filled in areas. I moved across the painting with brushstrokes. You can see in the detail that the dark area on the top right corner was put down first. The light yellow strokes beside this were put down next. The edges of the dark shape were created by drawing the lighter color into them. Sometimes the reverse was true, and the dark paint was drawn into the light. This is most easily seen in the final painting, where the curving lines of light are drawn more firmly by the darks around them. It can also be seen in the left foreground on page 57, where dark greenish colors are drawn into the blue sky reflection.

I want to emphasize here that drawing and painting become fused. Each mark is put down so it explains clearly the meaning of some previous touches of paint. They are all cumulative. The final touch brings it all together.

Painting is a thinking and a feeling process. You plan a picture, and you often change direction as you go along. You may even change your goal. The original idea may be nearly forgotten. As you proceed, the aim you first pursued is changed. There are painters whose aims do not deviate from their beginning sketches. But this is usually not true with a beginner. You may change your original idea often. I advise this not because your original idea may have been wrong, but because it is good to discover you can do things in more than one way.

Gozo Reflections differs from the other paintings I have shown you. It is more brilliant in color and appears more freely painted. I am often asked how I can have a free attitude toward painting when I spend so much time advocating great care with every brushstroke. I don't think my loose painting contradicts the idea of careful painting. The difference is in the way I work, not in the way I think.

Collias Reflection and *Gozo Reflections* were based on principles I have discussed throughout the book. Both paintings depend on understanding values and an ability to apply paint with accuracy. All the drawing was done while painting.

I worked rapidly with broad, sweeping brushstrokes. *Gozo Reflections* was done in 2-1/2 hours. This is one of a series I painted around the harbor of

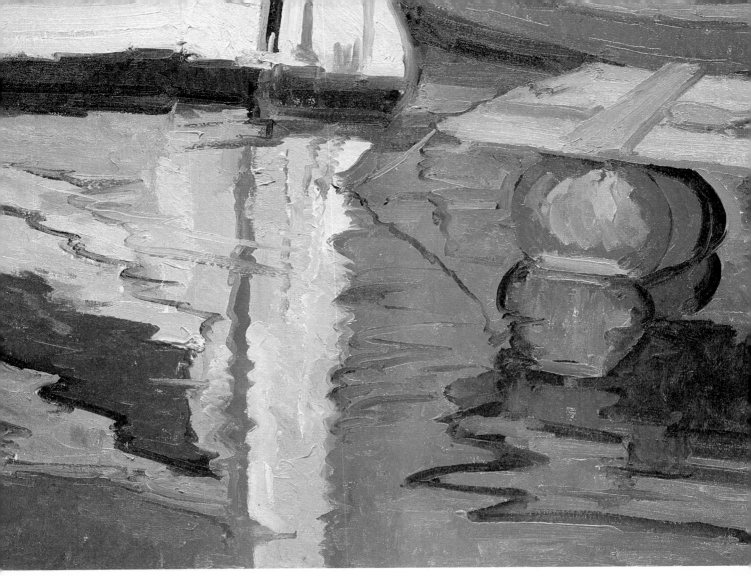

Gozo Reflections, 24x18''.

Gozo, a tiny island off the coast of Malta. Most of the paintings do not have boats in them. They are just reflections. Here I retained some boat parts because I wanted to paint the rusty iron barrel with wood on top. It would have been too isolated without the boats.

I started painting at the top and quickly put in the white boat and base of the blue boat. A few dark blue strokes took me to the edge of the barrel. There I painted the barrel's reflection before the barrel itself. Next came the dark reflection beneath the barrel and the dark lines coming toward the bottom of the painting. These helped establish the flat plane of the water.

The grayish white came next. My first concern was the straight downward part, which almost bisects the painting. I was not too worried at this point about the edge of this area against the blue

water shapes. I was more concerned with getting the correct color. Variations in this were painted as I went along, not afterward.

I worked at a varied pace. Sometimes I painted a large area, then drew a thin stroke across it. Try to paint like this. Don't deal with large areas first and then go on to details. The darker linear patterns were painted after the lighter areas. Finally, as the light began to fade, I painted the bottom left corner.

Painting With A Knife

I usually paint with brushes and my fingers. But when I work on a large scale, I sometimes use a palette knife. I like working with textures, applying one beside the other. Some painters prefer to use a palette knife all the time. As a beginner, there are two times when it is useful for you to paint with a knife. These are in addition to using a knife simply because you enjoy playing with thick gobs of paint.

First, if you find yourself *frequently* repainting parts of a picture, it's a good idea to paint with a knife. At least it will stop you from going over the same stroke several times. Second, if you are painting too thinly, use a knife.

There are no special subjects that are more suitable for painting with a knife than with brushes. With practice, you can paint as many details as you like, as long as you don't paint on too small a scale. For your first knife painting, choose a subject like *The Silk Farm* shown on page 63. Begin with a subject that doesn't have too many details. It will give you a chance to get used to a new tool. *The Silk Farm* was painted in four days. The stages illustrated on the following pages represent the points at which I stopped each time.

THE DRAWING

The drawing stage is the only time I used a brush in this painting. There would have been no advantage in using a knife. You want the drawing to indicate what you are going to paint and to show the main lines of composition. I expressed the darker areas fairly simply. I don't think there is any great advantage in doing this—it could be described as a nervous habit. I happen to like drawing in value contrasts. You may also find such a practice useful because it keeps you aware of the sense of light. I drew with ultramarine blue and a lot of turpentine. I used my paint rag often to wipe out incorrect lines while painting.

MIXING COLORS

Prepare a large quantity of paint when mixing with a knife. It may take a little longer than it does when using a brush. For mixing, it's easier to use the back of the knife. Be careful to mix the colors thoroughly. Traces of pure color left in the mixture may result in undesirable streaking when you are painting.

Some of the colors I mixed for the first stage are shown at lower left. I also mixed some greens. I used the basic color range plus lemon yellow and cobalt blue.

First Stage—I started at the top with the sky. I advise you to do this with your first knife painting. Work downward so you have no difficulty handling the knife. You can't do this throughout the entire painting, but it prevents awkward hand and arm contortions at first. The sky was painted with broad, flat strokes across the canvas. I then applied the top part of the distant hills. Every time you pick up a

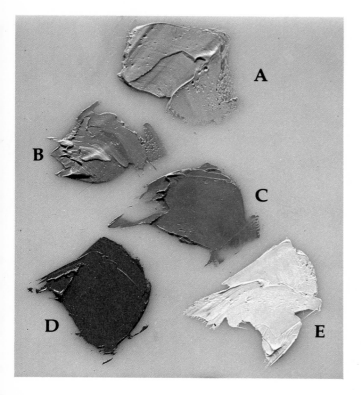

The color mixtures at left were used in **The Silk Farm**:
A—The sky: white, cobalt blue, cadmium red and yellow ochre, plus a touch of lemon yellow.
B—The distant hills: cobalt blue, white and cadmium red, plus touches of yellow ochre and lemon yellow.
C—The nearer hills: cobalt blue, cadmium red, yellow ochre and white.
D—The blue-accented hills: cobalt blue, cadmium red, ultramarine blue and white, plus a touch of yellow ochre.
E—The water tower: white, lemon yellow and red.

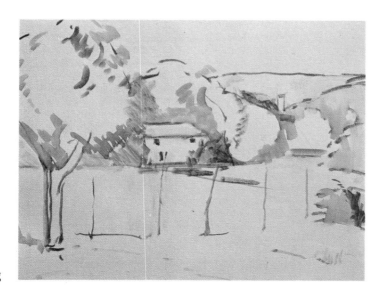

The drawing

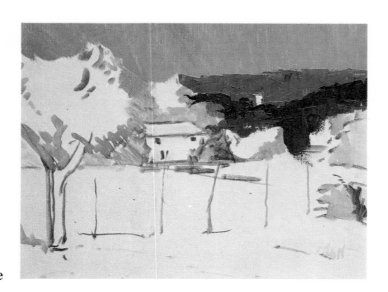

First stage

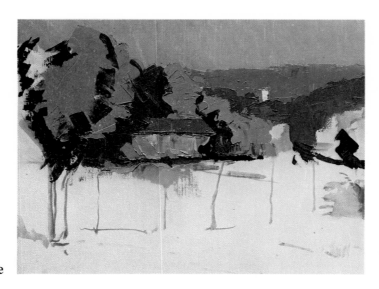

Second stage

61

Above and below: Details of the finished painting.

new color, make sure your knife is perfectly clean. I use a lot of paint rags, but large paper towels will do as well when painting with a knife.

The water tower came next. I painted it slightly wider than it was and corrected the shape with the distant-hill colors. The tower was followed by the nearer hills and then the accented hills. In each case I brought the color lower than I wanted. Then I placed the next color on top. You can see in the first stage where the paint of the distant hills comes below the accented hills. This painting method is easy if you don't overdo it—put it down once and leave it alone. With the exception of the water tower, these colors were applied by holding the knife horizontally and dragging it downward. Then I added two touches of paint to the accented hills—near the water tower—with the tip of the knife held vertically. The water tower was painted the same way, moving from right to left.

Second Stage—I began applying some of the greens to the canvas and started on the silk-farm building itself. This location really had been a silk farm—the building was long, so that a large piece of silk could be made and laid out. Silkworms lived on the mulberry trees, some of which still line the roads or were dotted around the fields. The near tree in this painting is a mulberry.

Compare this stage with the final painting, and you can see that the dark blue-greens and the color of the near tree were altered later. I wanted to establish the trees. It was easier to overstate these darks, knowing I would modify them. This practice has the disadvantage of making the color and values in the painting unbalanced. If you find altering colors difficult, don't paint unbalanced colors in the first place. Try to make the colors correct from the beginning, but err on the side of dark rather than light.

Next, I painted the roof of the house against the trees. I applied the dark stripe under the eaves. Then I painted the light-colored side of the house. The dark lines below and to the right of the house were used to mark where I wanted the house or trees to stop and the fields begin. If you compare the light side of the house with the final version, you can see it has been painted lighter. This lightening was done when the windows and door were added. I also painted the beginning of the tree trunk and the beginning of the field in front of the house.

Final Stage—In the fourth painting session, I began to develop the trees a little more. I first modified the foreground mulberry tree, making it lighter by painting over the dark colors. Then I went on to the big trees in the middle-distance. I mixed up three different colors for the grass. I varied these colors a lot as I painted. The dark color beside the near tree was altered. I began to repaint the house, making it

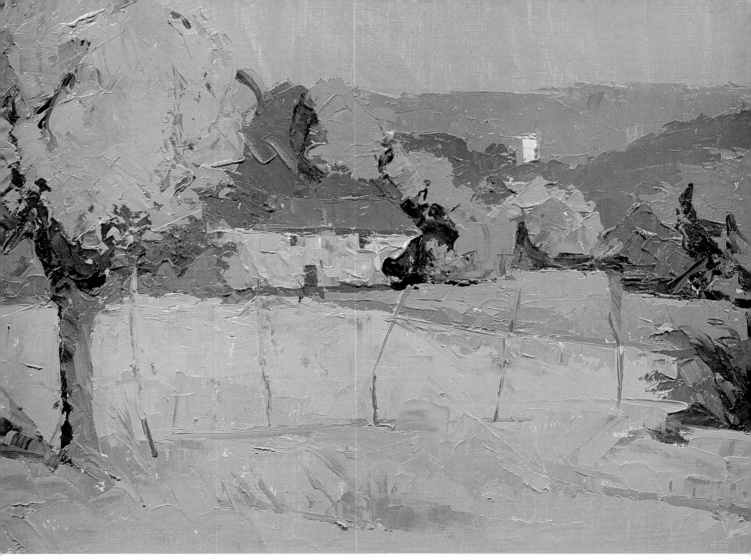

Final stage

The Silk Farm, 20x16''.

lighter and putting in windows and door. I drew some details on the grass and painted the fence.

The fence was first painted a dark color, then a light color. The last post on the right has been smudged, and this shows the darker color more clearly. The fence was painted when the green pigment was wet. Paint details like this with the side of the knife. Get a little paint along the edge and draw it upward or downward, depending on which is the easiest movement.

The windows and door were put down with the end of the knife in the same way as the water tower. First they were made a little too large and then corrected with the lighter, modified color of the house. The darker edge of the far field going up to the house was painted before the fence. The dark area at the base of the fence was painted after I had finished the fence. I first painted the middle values of the tree trunk on the left, then the light value. I finished with the dark touches down the side. The last areas I painted were the dark bush on the right,

and some darks in the trees beyond. I finished with small touches of light green trees in the dark paint beside the house.

I varied the way I used the knife, but the most frequent movement was from top to bottom of the picture. Sometimes it was easier to turn the picture on its side—such as when I corrected the angled end of the house. The paint overall was fairly thick except for the sky. Three weeks after I finished, most of the surface was still soft. I had to be careful when stacking this work against other paintings.

Painting with a knife is a simpler process than painting with a brush. Although it takes longer to mix colors, painting time is considerably quicker. It's best to paint without hesitation, to make up your mind what you intend before you approach the canvas. It requires a great deal of thought, then rapid action. It's more useful not to be too fussy about your technique of putting paint on canvas. Vary the strokes more and more as you paint more pictures with a knife.

63

Points To Remember

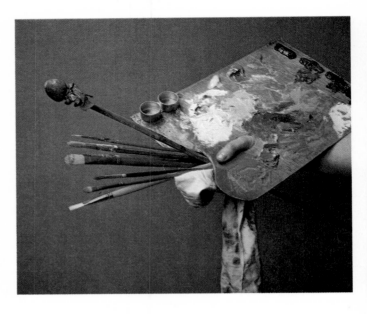

- Paint as much as you can from Nature.
- Don't change what is in front of you. If a tree is on one side of a landscape, don't move it to another side to make a better design.
- Make many sketch notes to work out something you don't understand after you have begun a painting.
- Paint over old pictures, but not those that are too dark in value, varnished or recently painted.
- Always mix paint on the palette, not on the picture.

- Use a palette knife if you are too vigorous when mixing colors on your palette with a brush.
- Use retouching varnish if you need to freshen up paint because it has become dull-looking while you are working.
- Don't thin paint too much.
- Take care of your brushes.
- Never work without a paint rag.

Index

6.4298357982